L.L. Bean
Outdoor
Photography
Handbook

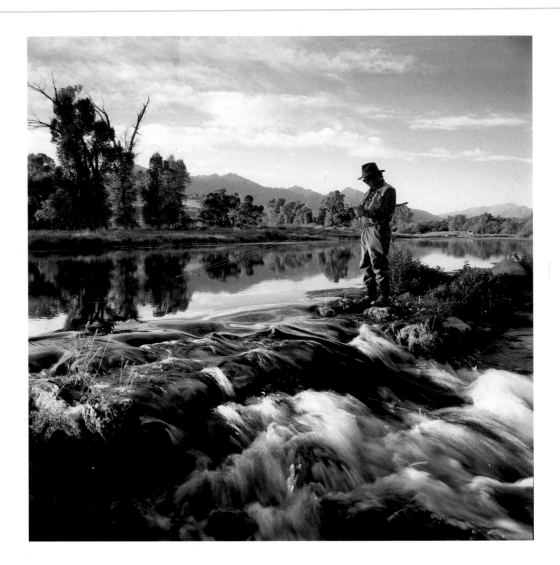

L.L. Bean
Outdoor
Photography
Handbook

JIM AND KATE ROWINSKI

The Lyons Press

Printed in Canada
Design by Compset, Inc.

10 9 8 7 6 5 4 3 2 1

Library of Congress Cataloging-in-Publication Data
Rowinski, Jim.
 L.L. Bean outdoor photography handbook / Jim and Kate Rowinski.
 p. cm.
 Includes index.
 ISBN 1-55821-879-3 (pbk.)
 1. Outdoor photography—Handbooks, manuals, etc. I. Rowinski, Kate, 1955– .
II. L.L. Bean, Inc. III. Title.
 TR659.5.R68 1999
 778.7′1—dc21 99-17165
 CIP

Contents

Acknowledgments

Over the years many people have taught us to take better photographs, and have helped inspire us to pass along the secrets to making good pictures.

Many thanks to Val Atkinson and Bill Silliker Jr., for advice and encouragement. You'll see a few of their photos in this book.

To Sister Naomi, of the Order of St. Benedict, who taught us how to distill a scene down to its most basic level. To Les Blacklock, who taught us to really *see,* and helped us find the hidden beauty of the natural world.

To the staff at Lyons Press, particularly Chris Pavone, who made the task of distilling our thoughts and images into a cohesive whole a pleasurable one.

To the people at L.L. Bean, for the opportunity to teach in their Outdoor Discovery Program and the chance to write this book.

And to our students, who over the years have taught us more than we could ever teach them, and who showed us, time after time, the wondrous things that enthusiasm and creativity can achieve.

Introduction

It's been over 25 years since we first picked up cameras and headed for the backcountry to try our luck at capturing some of the beautiful images that we'd seen from photographers such as Ansel Adams, David Muench, Les Blacklock, and Elliot Porter.

Along the way we've discovered an important truth. We could go out and try to duplicate the beautiful photographs of these masters—it was a great way to learn—but that wasn't enough. We weren't really expressing what we saw and felt; we were just re-expressing what these other photographers saw and felt.

Our images started to have emotional impact only when we followed our own instincts and intuitions. Suddenly the entire world of photo opportunities was ours; the only limitations were those that we placed on ourselves.

Photography, like any art form, has lasting impact only when it is original. It can come to life only when you put yourself and your emotions into it.

We also found that this can be a very frustrating form of artistic expression. Not until we were disciplined enough to really immerse ourselves in the technical aspects of photography did these frustrations start to ease. Once we had control of the basic elements of composition and exposure, we began to control our photographic destiny.

We've found that the secret to making consistently great photographs is first to have a command of the technical processes, and then—more importantly—to pour your passion into every image.

Teaching photography gives us nearly as much pleasure as photographing in the field. It is such a thrill to watch the lights go on inside students when all the pieces come together. Our greatest achievement is knowing that we helped students learn the technical aspects of photography well enough to capture images on film the way they saw with their eyes and felt with their hearts.

Another aspect of photography that has always motivated us is that it can take you to some of the most interesting and beautiful places on earth. It can also introduce you to fascinating people, customs, and ideas that you might not have known without the magic of camera and film.

The world is a kaleidoscope of sights, sounds, colors, and textures, all woven into unlimited possibilities for those who want to see and explore. Ours is a world of images limited only by our imaginations and our willingness to push ourselves beyond where we went yesterday.

We hope that this book will help you better understand the wonderful world of outdoor photography—and that it will help spark the fires of your own creative self. Thank you for sharing your time with us.

How to Use This Book

We have written this book following the syllabus we use in our outdoor photography classes. Because our classes generally contain a mixture of students with varying levels of skill and experience, we try to cover all the basics before we dig into the specific issues involved in taking photographs outdoors.

Here, these basics are covered in the first two chapters. If you're already comfortable with the workings of your camera and the intricacies of exposure and metering, you may want to skip this material. Or you may want to refer back only when you have a specific question.

If, on the other hand, you've been taking pictures awhile with little success, you may find it handy to review this information. It may be that all you need are a few subtle adjustments to your exposure settings and film choices to improve your photographs tremendously.

If you're brand new to this hobby, welcome! We hope that you, like us, find outdoor photography a wonderful way to experience the beauty, the energy, and the passion of the wide world.

Whatever your level, we hope that you'll find the information on these pages useful. We've designed it to be used in any way you wish: read it cover to cover, browse through the highlights, or simply keep it handy as a field reference. Sidebars throughout the chapters highlight the most crucial points, and a glossary at the back provides definitions of important phrases.

Good luck with your photos. We'll see you in the outdoors!

CHAPTER 1

Exposure, Light, and Film

The interrelationship between film and light is at the heart of the photographic process. Everything else is merely an accessory to these two fundamental elements. How the two react to each other is the most important thing you must learn to become a good photographer.

Many people assume that film is film, and that the camera knows what the **exposure** should be. They're content to let the photo fall where it may. But for the serious nature photographer, this isn't an option. Most of the joy of outdoor photography is in the details of light and color. The way you control these elements is by learning what films will bring out colors and what types of lighting will achieve the mood you're trying for. Understanding these elements is the foundation for all your future photographic success. Once you have a grasp of these fundamentals, the sky is the limit. You'll have the essential tools for making

your individual statement about how you see the world, and you'll find dozens of ways to manipulate every scene.

PAINTING WITH LIGHT

Light is the medium that you've chosen to record your creative ideas. A painter uses oil, acrylic, or watercolor as the medium. For you, the photographer, light is your paint. Fancy equipment, film, accessories, beautiful subjects—all are of absolutely no value unless you know how to control the light that comes into your camera.

> *Fancy equipment, film, accessories, beautiful subjects— all are of absolutely no value unless you know how to control the light that comes into your camera.*

Today's cameras are capable of doing most of the work of finding the correct exposure setting for a given scene. Modern equipment has become extremely sophisticated in the way it measures incoming light. But it would be a mistake to think that you don't need to know anything about exposure and metering systems. Although the camera uses a very specific set of rules that work much of the time, they are by no means perfect.

The camera's exposure meter is designed to give proper exposure for subjects of **middle tone,** the gray tone halfway between light and dark. The exposure meter chooses the correct exposure for recording your subject in the midrange between light and dark.

If the scene contains high contrast, many meters will try to average the light. This will leave the lighter areas burned out (overexposed) and the dark areas black (underexposed), a sure way to get an unsatisfactory photograph.

Some cameras have a spot-metering system that lets you choose the area of the frame you wish to have exposed properly. This makes things a little easier, but you alone should make the final decision on your exposure setting. Photography is a creative endeavor, and the way you control the light that strikes your film is the single most important factor dictating how your final product will look.

Certain lighting conditions can confuse the camera system; what you want well lit may not be what the camera is concentrating on, for instance. So even if you have a camera with **automatic exposure (AE)** settings, read your manual thoroughly so you understand how to override these automatic settings. Once you know how your camera works, adjusting your meter setting to suit your needs is usually a simple matter. Having a fundamental understanding of the way light works and how your camera measures light is the key to successful photographs. We'll address your meter options in more detail in chapter 2.

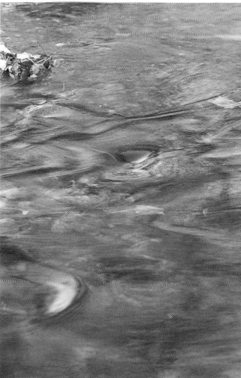

Color reflected on moving water is one of our favorite subjects for painting with light. By controlling the aperture and shutter speed, we can achieve an unlimited range of effects.

If you have a camera with automatic exposure settings, you should know how to override them. Read your manual carefully.

MEASURING AND CONTROLLING LIGHT

The light that comes into the camera is controlled by two settings—shutter speed and aperture. Each is represented in increments called stops. Each stop either doubles or halves, depending on which direction you are adjusting, the amount of light that reaches the film. Controlling the light that reaches the film is a matter of combining these two settings to create the effect you wish to achieve. Each control method provides different attributes, so understanding them independently will maximize your control over your images.

Shutter speed measures how long the shutter opens to let light reach the film plane. It controls how motion is recorded.

This bears repeating: shutter speed and aperture always work together.

Shutter Speed

Shutter speed measures how long the shutter will be open to let light reach the film plane. Most camera shutter speeds begin on the low, slow end with **"B,"** a symbol that stands for "bulb," the squeeze-ball shutter release that was the only option on early cameras. When your shutter-speed dial is set on "B," the shutter will stay open for as long as you hold down the shutter re-

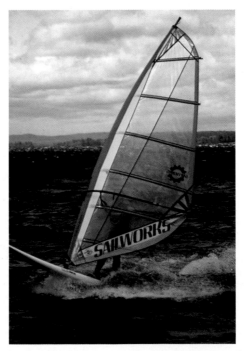

This windsurfer was captured at ⅟₅₀₀ to stop the action of sail and surf.

lease. The upper, fast end of the shutter-speed scale is anywhere from ¹⁄₁₀₀₀ to ¹⁄₄₀₀₀ of a second. Shutter speeds are referred to by only the denominator of the fraction—a speed of ¹⁄₁₂₅, for instance, is called 125, and this is how the speed appears on instruments. Therefore, the higher the number, the faster the shutter speed, or the smaller the increment of time that the shutter remains open.

Shutter speed is used to control how the motion of your subject is recorded—the less time the shutter is open, the more that the motion is frozen. For example, if you shoot a running deer at ¹⁄₆₀, he will probably come out blurred, because you've captured his motion over the course of ¹⁄₆₀ second. This may not seem like a long time, but for a quickly moving object it is. But if you shoot the deer at ¹⁄₂₅₀, you'll probably succeed in fully stopping his motion.

Conversely, you can shoot an absolutely stationary object at as slow a shutter speed as you wish, if you can control all motion of your camera or subject. (These objects are very rare in nature photography—there is virtually always some sort of breeze!)

The most common shutter speeds that you will find and use on various cameras are 1 second, ½, ¼, ⅛, ¹⁄₁₅, ¹⁄₃₀, ¹⁄₆₀, ¹⁄₁₂₅, ¹⁄₂₅₀, ¹⁄₅₀₀, ¹⁄₁₀₀₀, ¹⁄₂₀₀₀, and ¹⁄₁₀₀₀.

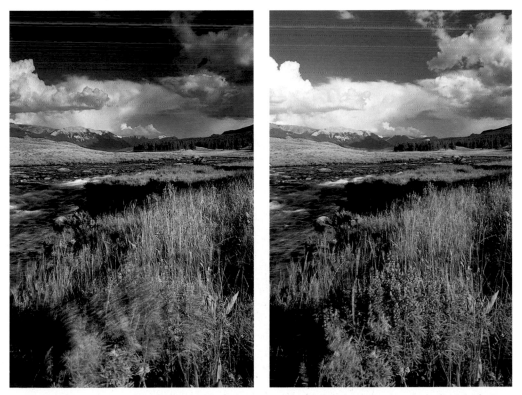

There seems to always be wind to deal with. Patience is needed. Be ready when the wind stops for a brief moment to get your shot.

To understand how the camera shutter works, open up the back of your camera (without film in it!). Take the lens off the camera or open the aperture on the lens to its widest opening, which will be a measurement such as f1.4 or f2.

Set your shutter-speed dial at "B" and press the shutter-release button, just as though you were taking a regular picture. The shutter will stay open as long as you hold down the button. Now set it at 1 second and release the shutter—notice that a full second seems like a long time. For photographic purposes, it is. Now work your way through the entire set of shutter speeds on the dial and watch how quickly the shutter opens and closes. This will give you a good sense of how much light reaches the film for each different shutter speed.

As you work from 1 second through the faster shutter speeds, the time is reduced by half at each subsequent shutter speed: ½ second is half the time, and half the light, of 1 second, but ⅟₁₂₅ is also half the time, and half the light, of ⅟₆₀ second. The faster the shutter speed, the less light is allowed onto the film.

Now let's reverse the procedure. A shutter speed of ⅟₁₂₅ is half as fast, or twice as much light, as ⅟₂₅₀; ⅟₃₀ is half as fast, and twice the light, as ⅟₆₀. The slower the shutter speed, the more light is allowed to be exposed to the film.

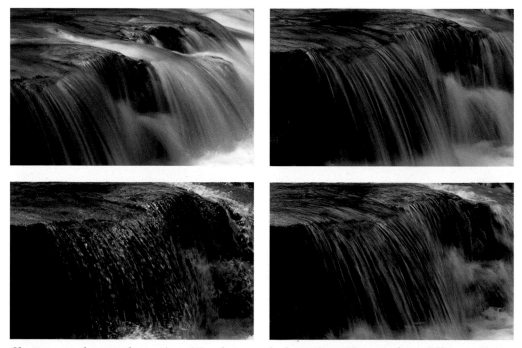

Shutter speed controls motion. We photographed moving water at four different shutter speeds to show the different ways we can capture motion. Slow shutter speeds such as ¼ second blur the action and make the water appear smooth. Faster shutter speeds such as ⅟₁₂₅ second render the water motion as we see it with our eyes. Clockwise from top left: ¼, ⅟₁₅, ⅟₆₀, and ⅟₁₂₅ second.

So shutter speed controls the amount of motion recorded in your photographs. You'll require shutter speeds of ⅟₁₂₅ and higher to *stop* motion. For example, ⅟₁₂₅ may stop the movement of a swimmer, but catching bicycle racers might require ⅟₅₀₀. Slower shutter speeds (⅟₆₀ and lower), on the other hand, will create a blurred image if your subject is moving.

Of course, shutter speed isn't the full story; now we're ready to add aperture setting to the exposure equation. These two controls always work together.

Aperture

Aperture is the measurement that indicates the size of the lens opening. This, along with the amount of time that the lens is opened, determines how much light will reach the film. Aperture settings are known as **f-stops,** and are designated by the letter "f" followed by the size of the opening; these settings are found on the lens itself. Each lens has a different range of aperture settings based on its speed. (Lens speed is determined by the largest aperture setting for the lens. Faster lenses have wider aperture openings, such as f1.2 to f1.8. The largest aperture opening on slower lenses is f2.8 to f5.6.)

Standard aperture settings range from f1.4 to f32, but each lens may have a different range of aperture numbers. The smaller the number, the larger the lens opening. An f1.4 aperture creates a large opening; an f32 creates a very small opening.

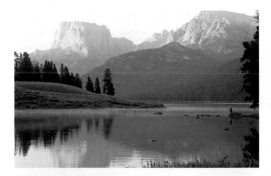
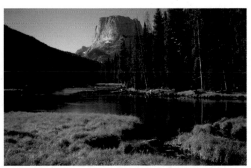

The combination of shutter speed and aperture controls the amount of light that strikes the film. This sequence of photos shows the exposure differences from 1 stop overexposed (top left) to the correct exposure (top right) to 2 stops underexposed (bottom).

The most common aperture settings you'll find on a lens are f1.4, f2, f2.8, f4, f5.6, f8, f11, f16, f22, and f32. Each number in the series, working from the largest opening of f1.4, will transmit half as much light to the film as the previous number. For example, f2 transmits half as much light as f1.4, and f11 allows half as much light as f8 to reach the film.

In reverse, f8 transmits twice as much light to the film as f11, and f1.4 allows twice as much light to expose the film as f2.

Play with your lens to see what we mean. As with shutter speed, an easy way to understand aperture is to take your lens off the camera. Look through the rear of the lens and turn the aperture settings from largest to smallest. Turning the aperture to the largest number, probably f22 or f32, will create a pinhole opening. Turning it to the smallest number, f1.4 or f2, will create an opening almost as large as the entire width of the lens. Every f-stop represents a halving or doubling of the light you will let into the camera through this opening. Nearly all 35mm SLR cameras will also allow you to adjust apertures by ½-stop increments. These are the spaces between the "clicks," which allow you to fine-tune the amount of light for a given exposure. Some cameras also have a separate exposure-compensation button that modifies the exposures in ⅓-stop increments.

Aperture controls **depth of field,** the amount of the image frame that will be in sharp focus. A very small aperture opening will create an image that has most of the frame in focus. In con-

> *Aperture is the measurement of the size of the lens opening that lets light pass through the camera. It controls depth of field—the amount of the image frame that will be in sharp focus.*

Aperture f-stops.

trast, a large aperture will have only the central subject in focus—the background and foreground will be thrown out of focus.

The key to getting the exposure you want is finding the appropriate combination of aperture and shutter speed. Though any situation may be shot with a variety of correct combinations, not every combination will look the same. A high shutter speed with a large aperture

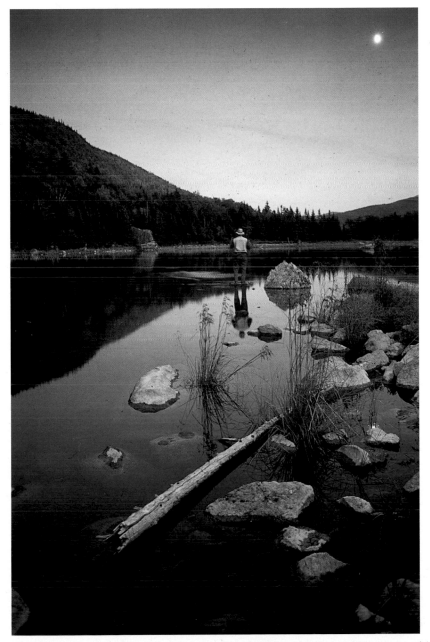

A 1 second exposure at f32 gave us enough depth of field in this shot to bring everything into focus, from foreground to infinity.

will capture the motion of a central subject in good detail. A slow shutter speed with a small aperture will give you excellent depth of field, and everything in the frame will be in sharp focus, although any movement will be blurred. Try shooting different exposure combinations of a subject and see for yourself the differences in sharpness or depth of field.

LIGHT CONDITIONS

There are a number of conditions that cause special concerns for the nature photographer.

Bright Sunlight

You'd think that a bright, sunny day would be a perfect time to shoot pictures outdoors. But bright sunlight creates its own special issues. Because of the way light is reflected, your meter's exposure reading can be thrown off by bright surfaces such as water or sky, as well as by dark surfaces such as a deep green forest. That's why it's handy to learn the **Sunny 16 Rule,** a quick way to estimate the correct exposure setting for bright conditions. It's also a handy backup system if you suspect your meter is malfunctioning.

Learn the Sunny 16 Rule, a handy way to estimate the correct exposure setting for bright conditions.

Sunny 16 Rule

$$\text{Shutter Speed} = \frac{1}{\text{ISO speed}} \text{ at f16}$$

Using this equation, your aperture is always set at f16. If you're shooting with ISO 125 film, your shutter speed should be set at $\frac{1}{125}$ second. You can round off to the nearest number, as long as it is within $\frac{1}{3}$ stop—if you're using ISO 100 film, then, you should get a good exposure using a shutter speed of $\frac{1}{125}$ second.

With the Sunny 16 Rule, always bracket to ensure that you capture the exposure you want. **Bracketing** means shooting at $\frac{1}{2}$ to 1 stop under the recommended exposure, then shooting again at $\frac{1}{2}$ to 1 over the recommended exposure. Of course, you'll also take one shot at the exposure you believe is correct.

The Sunny 16 Rule can be the basis for determining your exposure in a number of conditions. If your shot is made up primarily of water or snow, stop down 1 to $1\frac{1}{2}$ stops from this setting. If conditions are hazy with no shadows, open up 1 stop.

High-Contrast Subjects

On some occasions you'll run into a scene that has virtually every value of light in the spectrum. Unfortunately, your camera will be able to pick up only some of the subtleties that your

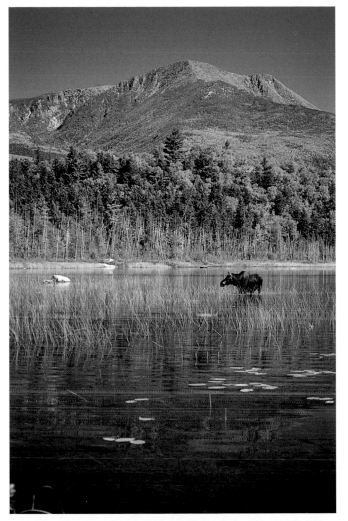

This is a great example of using the Sunny 16 Rule: f16 at ¹⁄₁₂₅ with 100 speed Fujichrome Provia.

eye can see. Your job is to choose which values are most important to you and find the balance that will achieve your purpose.

If the primary area of interest is in the darker portion of the frame, open up your exposure setting 1 or 2 stops above what the camera suggests. Remember that the brighter portion of the shot may **blow out**—that is, all detail will be completely erased.

On the other hand, if this brighter portion is what you hope to capture, simply stop down 1 or 2 stops from the camera's suggested setting. This will send the darker portion of the frame nearly to black.

Is it possible to have it all? Often it is, if you're willing to bring a few accessories along. Reflectors can bounce a little extra light into the shadowed area. Or you can diffuse or even

block sunlight from hitting the brighter spots in the shot. Of course, this only applies to scenes small enough to control. Shots of people and close-ups can easily be controlled with a few accessories. We'll tell you more about these accessories in future chapters.

Back Lighting

Backlit subjects can be some of the most frustrating, but also some of the most potentially rewarding. Light that comes from behind your main subject accentuates its shape, and this can create powerful silhouettes. A silhouette is created by exposing for the lighting *behind* the subject.

If you prefer to see your main subject in detail, you'll need to take your meter reading directly off the subject. If you can approach the subject, use your camera's meter to determine its proper exposure. Then step back and shoot using this setting. Try to crop or remove extremely bright or distracting areas of contrast, such as a slice of sky.

If you can't approach the subject, try estimating the exposure. Using the Sunny 16 Rule, you know the proper exposure for the image. Just open up 1 or 2 stops to get the detail in the main subject.

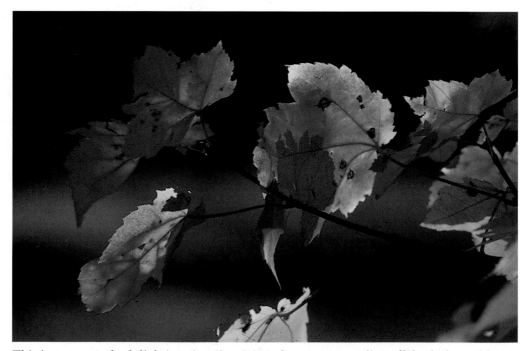

This is a common back-lighting situation. We took our meter reading off the darker red leaves and overexposed by ½ stop. We also positioned the camera to give us a dark contrasting background and purposely set our exposure for a shallow depth of field so only the leaves were in sharp focus: f4 at ½₁₂₅.

You may also be able to get an idea of the proper exposure by using a **gray card,** a piece of cardboard that is an 18 percent reflectance middle-tone gray color. Such a card will allow you to find the proper midtone reading for your light. You can then stop up or down to adjust for the subject's color.

Sometimes back lighting casts a beautiful aura around your subject. To capture this **rim lighting,** you'll need to find an exposure somewhere between the bright light and the dark tones of the subject. Try to meter right to the subject, then open up 1 stop.

In awkward light conditions, a gray card can help you find the proper midtone reading.

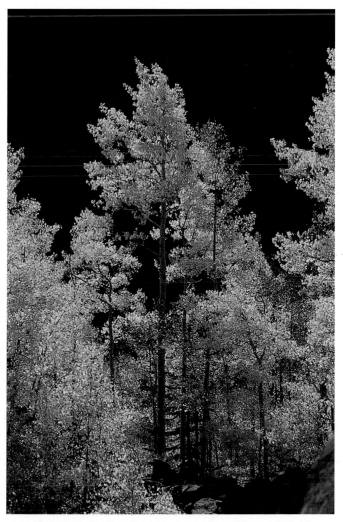

Back lighting causes these late-September aspens to glow. We used the Sunny 16 Rule and stoppped down 2 stops to get detail in the leaves.

To capture rim lighting such as you see on this moss, meter right on the moss, then open up 1 to 1½ stops.

As always when experimenting like this, bracket your images! It's easier and ultimately less expensive to bracket your photos in the camera than to try to compensate during the development process.

Low Light

The edges of light are the times of day when many outdoor photographers most actively search for the magic light. Early morning and late in the day can be special moments when light sets everything aglow. These are the times when you can capture the mood and emotion of the landscape at its finest.

Often, however, the aperture setting you need to let in the right amount of light won't match the depth of field you're trying to achieve. Or the slow shutter speed can't capture the motion you're after. To complicate matters further, the lighting at dawn and dusk is ever changing, shifting moment by moment.

To capture these many moods requires quick thinking or a lot of bracketing or both. Check your meter reading often. As the sun goes up or down, the light changes every minute.

For shooting sunrises and sunsets, take your meter reading off the sky or a nearby midtone object—and don't include the sun in your viewfinder while metering.

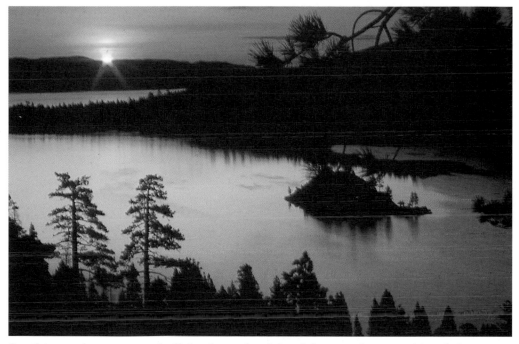

For this sunrise we metered off the sky to the right of the sun, then repositioned the camera for the shot.

If you're shooting the sunrise or sunset, make certain that the sun is not in your viewfinder when you take your meter reading. Take your reading off the sky to either side of the sun, or on grass or foliage nearby that's a middle tone compared to the surrounding colors.

WHAT IS FILM?

If light is your artistic medium, then film is your canvas. Your camera helps control the way light is applied to your canvas; in the same way, your choice of film affects the way the light translates into an image. We don't want to belabor this painting analogy, but it's helpful to remember that every one of your photographic choices plays a role in the type of photograph you'll create.

We often find people at our slide shows complaining that they've been in the same places we were, but their images didn't come out the same—and we often learn that they were shooting with print film, a very different medium from slide film, which is our choice. Of course, there may be other reasons why they have not achieved the image they wanted, but the point is, don't com-

> *Just as your camera helps control the way light is applied to your canvas, so your choice of film affects the way the light will translate into an image.*

pare apples with pears. Know what you wish to achieve before going out and purchasing your film.

CHOOSING THE RIGHT FILM

The first decision to make is what medium you'd like to work in. Color prints, color slides, and black-and-white prints have very different qualities and very specific strengths and weaknesses. Spend enough time researching the differences among films to understand how they act and what film will be the best choice for the type of images you want to achieve. The success and enjoyment of your final photos will increase dramatically once you understand the potentials of the various types of film.

Color Slide Film

Color slide film is great for preparing shows and presentations—we love the intensity of the colors and light it provides. And most publications prefer to use **transparencies.** So this film is generally our choice.

Color slides are viewed by transmitted color, rather than reflected color. That's why the intensity and saturation seem so brilliant. But you have to use projection or enlargement to really appreciate them. And their tendency toward higher contrast allows very little latitude for over- or underexposure, so there's less room for error. We often underexpose our slide film slightly, maybe ⅓ stop below our meter's suggestion, which can create richer, more saturated colors. If you decide to try this, bracket ⅓ stop over and under so that you can see the difference for yourself. And this will increase the chances that you have captured the image the way you want it.

There are two types of slide-processing systems. Kodak's Kodachrome films use a C41 process and must be processed by a Kodak facility; your local film dealer may have to send your film away, which can take two to five days. Most other slide films use the E-6 process, a far more accessible type of processing that can often be done in one to three hours. Slides can be made into prints, but the average processing house often produces a higher-contrast image than the original slide. Up to 90 percent of the professionals producing images for magazines and catalogs use slide film.

After you've seen the brilliance of the original slide image on screen, prints can disappoint you if they're not processed by a company that specializes in slide film printing. Chromes, as they are called, are also more expensive prints than those made with standard print film.

Color Print Film

If you love to create photo albums and fill the house with framed photos, **color print film** is your obvious choice. It's the most common form—90 to 95 percent of all film sold is color

print film, most of it for nonprofessionals—so your film options are abundant, and processing is available almost anywhere. Exposure tolerance is greater than for slide film, which can make it easier for you to get a good shot. Color variations are more subtle, and because you're working with a **negative** as the intermediary step to your print, color and exposure problems can more easily be worked out in processing.

Black-and-White Film

Black-and-white prints are great for drama, for simplicity, for fine art. And an added advantage is that it's relatively easy to set up a black-and-white darkroom in your home; this provides you with a lot of control over your images, and lets you add printmaking to your creative process. The downside is that processing-house black-and-white processing is often unsatisfactory: the subtleties and adjustments you can achieve in a home darkroom just aren't possible in a mass-production processing house. So if you love great black-and-white images, consider taking the next step and getting a darkroom.

Which medium is right for you? Color slide film is great for shows and is the preference of magazine and book editors. But if you like to create photo albums, color print film is a better choice. Black-and-white film is great for drama, for simplicity, and for fine art.

FILM ATTRIBUTES

Speeds

Film speeds are designated by the film's assigned **ISO number** (formerly called the **ASA number**); this is a measurement of the different film emulsions' sensitivity to light. The higher the ISO film-speed number, the more sensitive it is to light, which means that you need less light for proper exposure. An example of a slow film is Kodachrome ISO 25; a fast film is Kodacolor ISO 400.

Film speed is measured in stops, just like aperture and shutter speed. In most cases the doubling or halving of an ISO number also doubles or halves the film's sensitivity to light: ISO 50 to ISO 100 is an increase of 1 stop; 50 to 200 is an increase of 2 stops; 50 to 400 is an increase of 3 stops—that is, ISO 400 speed film is three times more sensitive to light than ISO 50 is, so it needs three times less light for a proper exposure. The most common film speeds are ISO 25, 50, 64 (⅓ stop from 50), 100, 200, 400, and 800.

When you can combine film-speed stops with aperture and shutter-speed stops, you're well on your way to controlling your final exposure. Here's an example of these three elements working together: for a given shot, a film whose speed is ISO 50 might be properly ex-

posed at ⅟₆₀ at f11. If you change to ISO 200 speed film, however, you'll have to accommodate for film that's 2 stops faster. You could adjust your shutter-speed setting to ⅟₂₅₀ at f11. But you could also adjust your settings to ⅟₅₀₀ at f8, or, going the opposite direction, to ⅟₆₀ at f22 or ⅟₃₀ at f32. All of these settings would give you the same *exposure*. However, they may not give you the same *result:* f32 will give you greater depth of field, and ⅟₅₀₀ second will stop action. What is your intent?

Faster films tend to make images that are a little grainier than slower films, a drawback if you plan on enlargement. Films have improved tremendously over the years in this respect, so this may not concern you much unless you're blowing up a photo very large or using it for publication.

We generally use the slowest film we can get by with for the particular subject we're photographing, because slow films are less grainy and give us the sharpest images possible.

Color Sensitivity

The emulsion of the film can also be modified for almost any degree of **color sensitivity.** That's why after you have been shooting awhile, you'll probably develop a preference for a certain type of film.

Some films are naturally warm: Fuji films and slower Kodak films such as Kodachrome 25 and Royal Gold 25 bring out a scene's yellows and reds. Others tend to be cooler, such as Kodak Ektachromes, and make the most of a scene's blues and greens.

Slide film tends to be more sensitive in this respect, a lesson we learned the hard way many years ago. We had a shoot where half the film came out fantastic and half was awful. We couldn't figure it out until we remembered that halfway through the shoot, we had run out of film. We'd gone into the nearest town to buy more. Definitely not our normal film, but no problem, right? *Wrong!* The second batch of film was very cool compared to the film we'd been using, and suddenly our luscious reds and yellows were flat and lifeless. We should have known better. After all, we knew that films had different properties.

This was the most striking example we had ever seen of the difference film can make. Now we have very definite film preferences for various conditions. For example, we rarely shoot a wedding (which calls for a film with softer, more pastel colors) with the same film that we'd use to shoot autumn leaves (whose film should bring out oranges, yellows, and reds).

We suggest that you read the manufacturer's literature that comes with your film, experiment with different kinds, and decide for yourself which films are right for you.

Bottom line: there are more great film choices today than ever before. Find a film or two that you enjoy working with and learn how it works in different conditions. This will make a significant difference in your photographs.

A warm film such as Fujichrome brings out reds and yellows. This is our first choice on over-cast days, because it balances the cool bluish tones.

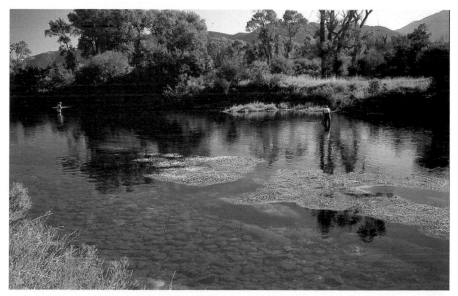

A cool film such as Ektachrome accentuates blues and greens, and can also give crisp white clouds.

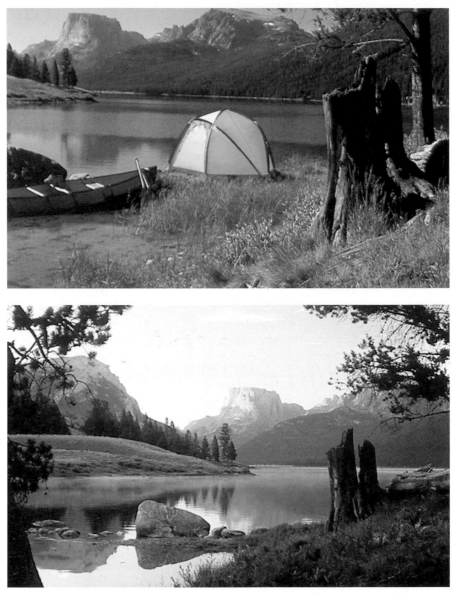

The top image was taken at the beginning of our shoot with Fujichrome. Notice how warm the colors are compared to the bottom shot, taken the next day with another film.

CHAPTER 2

Equipment

The myriad choices of camera equipment available to the beginning photographer can be bewildering. Today's cameras feature such an extraordinary range of options that it's often difficult to know where to begin your research. It helps to remember that the camera is just a tool, a way to help you apply light to film.

So before investing in your first piece of equipment, ask yourself a few questions. What type of pictures do you want to take? Do you like photographing people, or are you anxious to try close-up photography? Are you looking forward to wildlife photos? Your answers will give you a foundation from which to begin.

You don't have to worry about addressing all possibilities right away. But beginning with the right system will ensure that you will have the opportunity to build your camera outfit over time.

THE CAMERA

Your first consideration is which camera to buy. If you're pretty certain that you're going to make this your hobby, you should begin with as good a 35mm camera as you can afford. The most versatile type of 35mm camera is the **SLR,** or **single-lens-reflex** camera. Unlike the typical point-and-shoot camera, which uses a separate viewfinder for composing pictures, the SLR employs the same lens for viewing the scene as it does for recording the image on film. This gives you more control over composition and focus, because the scene that you record on the film is *exactly* what you see through the camera's viewfinder.

Today's SLRs come with myriad options. Consider your needs as well as your pocketbook when choosing which features are important to you.

The 35mm SLR is especially versatile because you can change lenses to suit your specific needs. With the more sophisticated models, you also have the options of changing your viewing screen and adding motor drives and other accessories.

Today's SLRs range from the basic, manually operated type to highly sophisticated models that have electronic controls for everything from exposure and focus to built-in film advance. Consider how much control you wish to have over your images when choosing which features are important to you.

Exposure Control

The camera's method of handling exposure is the first thing you'll want to consider. Do you want **manual exposure control,** or are there times when **automatic exposure (AE),** or automatic metering, will best suit your needs? The primary consideration is how much control you want. Some photographers consider manipulating exposure an essential part of their work—they want complete control over factors such as motion, depth of field, and color. But if you enjoy composing and shooting without having to fret too much over settings, you may find that the automatic option is right for you. Or if you do a lot of action photography that requires speedy shooting, a fully automatic option may suit your needs. Many of the fully automatic models come with a variety of exposure modes: one mode selects your aperture as well as your shutter speed; other modes allow you to choose the desired aperture while the camera selects the appropriate shutter speed; or you can select the right shutter speed and let the camera select the aperture.

Keep in mind, though, that automatic settings are not foolproof. Because complex lighting conditions, such as bright sunshine and deep shadows, can fool a camera's meter, automatic metering provides an accurate exposure only about 80 percent of the time. You'll still need a good understanding of f-stops and shutter speeds, so that you can override your camera's

choice when necessary. Automatic-metering cameras generally include a manual option, so you have complete control whenever you wish.

Metering Methods

It's important to know what metering method your camera uses, so that you can understand how it arrives at its choice of exposure settings.

Center-weighted metering measures all the light in the viewfinder, but concentrates 75 percent of the meter's sensitivity to the center portion of the camera's viewing area. This is great when the subject is in the center of the picture.

Spot metering is more specific, concentrating the meter reading to a center circle that ranges from 3 to 10 percent of the viewfinder. This type of metering is handy when you want to precisely measure a portion of the scene: a spot meter can read the light off an animal in the field without incorporating any of the background light into its calculation. This ensures that your main subject is properly exposed.

Matrix metering considers brightness, contrast, and distance to determine the best exposure for the image area. This method of metering probably provides the highest degree of accuracy, even in complex lighting conditions.

Whatever method your camera uses, you alone are the judge of what exposure is best for your subject. The keys to successful exposure are to know in advance how you want the photo to look, and to understand how your camera arrives at its suggested exposure reading.

Shutter Speeds

You'll also want to know what range of shutter speeds is available on the camera. Most cameras have fast shutter speeds that are adequate for most applications—$\frac{1}{1000}$ will cover nearly all of anybody's needs. But if you intend to capture special subjects at close range, such as racing cars or galloping horses, you may want to have shutter speeds that go higher.

Take a close look at the slow end of the camera's range, however, to make sure you have the versatility you need for low-light conditions. Some cameras only go down to $\frac{1}{8}$ second. We don't feel that this is slow enough for many of the shots we like to take; many of our photos require shutter speeds of $\frac{1}{2}$ second or longer. We like shutters that will provide an accurate exposure to 4 seconds. Many cameras have a "B" setting that allows you to open the shutter for as long as you hold down the shutter release. These are fine for very long

Automatic metering is a convenient option, but it provides an accurate exposure just 80 percent or so of the time. Only a good understanding of exposure settings will allow you to override your camera's choice when necessary.

exposures, but when you want an exposure of only 1 or 2 seconds, they're not accurate enough.

Focusing Screens and Viewfinder Accessories

The **focusing screen** is the piece of glass inside the camera on which the image is viewed. Take a look at the screen inside the camera you're considering. Most cameras come with a split-image screen, which works by aligning the image in the center of the viewfinder as you turn the lens's focusing ring. Most cameras come with a stationary focusing screen that can't be changed, so be certain you're comfortable with it before you buy.

Still, some cameras do offer interchangeable screens. With this option you can choose from over a dozen different screen types. We prefer a clear matte screen for many field situations, because it lets us view the entire image without distraction. Or you may find it easier to compose and focus using another type of focusing screen—for example, some have grids that help you line up horizons and vertical lines. While we don't change our screens much, we like having the option to customize our cameras to suit our preferences.

If you wear glasses, you might also benefit from an **eyepiece correction lens,** an attachment that screws onto your viewfinder to help you see more clearly. Some manufacturers make adapters for a wide range of eyesight requirements, so ask your camera shop's staff what's available for your camera.

Manual or Auto-Focus?

The new **auto-focus** options let you shoot quickly without fussing with fine focus. This is especially handy if you're shooting moving subjects, such as children and wildlife. We use Nikon's automatic-focus tracking, which automatically engages when the subject moves, and locks onto the subject even if something else momentarily gets in the way. Also, the auto-focus feature can give you an accurate reading in low-light conditions where your eyesight may fail. And all auto-focus lenses give you the option of switching to manual focus for tighter control of your subject.

Depth-of-Field Preview

Make sure your camera has a **depth-of-field preview** button. This button stops down the lens to the designated aperture setting so you can see exactly how you're shooting the scene. When you view the scene with your lens wide open—the typical procedure—you don't get a good idea of your depth of field. The preview button shows you how much of the scene is in focus before you shoot.

Motor Drives

Motor-driven film advance is also built into many of the new cameras. Some cameras offer a range of film advance speeds, which allows you to set the speed that's right for your situation. A simple 1-frame auto-advance conveniently moves your film ahead after each shot. A low-speed advance shoots 2 frames per second—perfect for filming a sequence of events. High-speed advance shoots 4 or more frames per second, to maximize your chances of capturing that peak moment of action.

LENSES

As wonderful as all these camera options are, it's your lens that'll really tell the tale when it comes to the quality and appearance of your images. Since you can use your SLR with an extraordinary range of lens options, it's important to understand some of the basics of lens construction before you select the lenses that are right for you.

Angle of View

Lenses are described by their **angle of view,** the amount of area that they show in front of the camera. Angle of view is determined by the **focal length** of the lens, measured from the optical center of the lens to the film plane.

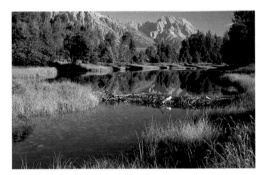

The same scene shot with three different lenses, from top left to right 28mm, 55mm, and bottom 105mm. You can purchase these three lenses separately or buy one good-quality zoom lens that will cover the same focal lengths.

Chances are that your new camera came with a 50 or 55mm lens; these are called **normal lenses,** because they provide an angle of view that's close to that of the human eye, about 45 degrees. They're good all-purpose lenses, so start shooting with this size before you decide what your next purchase will be.

Wide-Angle Lenses

Lenses with short focal lengths are called **wide-angle lenses.** These show more of the scene than the eye would normally see if looking out of a simple viewfinder frame. A wide-angle lens accomplishes this by bending the light that passes through it, optically shrinking everything it sees and fitting more onto the viewing screen. The extreme end of the wide-angle spectrum is the **fish-eye lens,** which optically distorts a wide area and fits it into the viewing area. These lenses can practically see backward—a 6mm version can take in as much as a 220-degree angle of view. Fish-eyes are fun to play with but impractical to own: their application is very specific to scientific and architectural types of work.

A practical choice of wide-angle lens for your basic outfit starts at 24 or 28mm; these provide you angles of view of about 84 and 75 degrees, respectively. They're the lenses of choice for landscapes. But they're also handy when you're shooting on the run: the picture angle is large, the depth of field is wide, and you can shoot fast without a lot of worry about focus. And because the optics usually offer larger aperture openings, you can shoot in a wide range of lighting conditions.

Remember, wide-angle lenses shrink everything, so your subjects can disappear if you're not close enough! Wide-angles also distort the images somewhat, so certain features can appear disproportionate: if part of your subject is closer to you, it will appear oversized compared to the rest of the subject. This is well illustrated with the "trophy fish" shot: a fisherman holding his fish in front of a normal 50mm lens will have a nice fish; but take that same photo using a 28mm lens—now that's a fish!

Short Telephoto Lenses

A **short telephoto lens** (85 to 135mm) is a must for candids or family portraits: it lets you fill the frame with your subject without having to get too close, so you eliminate any perspective distortion. These lenses also have a shallower depth of field, letting you put distracting backgrounds out of focus, and more easily isolate important details in the landscape.

Long Telephoto Lenses

Long telephoto lenses are used for wildlife photography and sporting events. They pull in distant scenes, allowing you to bring in subjects that would be out of a normal person's range

of view. There are a number of telephoto lenses on the market, with a wide range of price tags. The quality of the optics is crucial, so buy the best you can. Note the aperture opening: lenses go up in price significantly if they can open 1 or 2 stops wider than others. For wildlife, you'll want to begin with a 300mm or 400mm lens. A 300mm is about the longest lens you can hand-hold, and anything 400mm or over will require tripod support. Serious wildlife photographers also have super-long (over 400mm) telephotos in their gear bags. These are expensive and heavy, but if you become serious about wildlife photography you may eventually want to add one to your outfit.

Zoom Lenses

There's a range of **zoom lenses** on the market, and they make a handy alternative to carrying a lot of different fixed-focal-length lenses. But because the optical requirements of zooms are more complicated, make sure to buy the best you can afford, or you may be disappointed by the image quality. Keep in mind that a zoom lens is a little heavier than a fixed-focal-length lens, so it may be harder to hand-hold. It also may have a larger minimum aperture than you could get with a fixed-length lens; this can be a problem with wildlife photography, where your best shots often come at the beginning or end of the day when available light is limited. A fixed length 300mm f2.8 lens may be affordable, but a 75–300mm f2.8 lens may be impossible to find, or out of your price range. You're more likely to find a 75–300mm f4.5–5.6 lens, but this will cut your ability to capture available light in half.

A great all-purpose field outfit would include four lenses: 24mm wide-angle, 50mm normal, 105mm short telephoto, and 300mm long telephoto.

Eventually, you'll want a range of lenses that are roughly double one another. A great all-purpose field outfit would probably include a 24mm lens, a 50mm lens, and a 105mm lens. From there you should decide what lenses best fit the type of photography you like. Our next purchase was a 300mm lens, because it's more useful for wildlife than a 200mm is. Every photographer's ideal field outfit is different. Don't hurry with your decisions. The more you shoot, the better you'll understand your own needs.

CAMERA SUPPORTS

A **tripod** is the single most important piece of equipment, after your camera and lens. Mounting your camera on a tripod is absolutely essential for shots that require a long lens, a slow shutter speed, or close focus. But we also find that using a tripod all the time improves *every* shot we take: there is no question that we improve the sharpness of our photos because

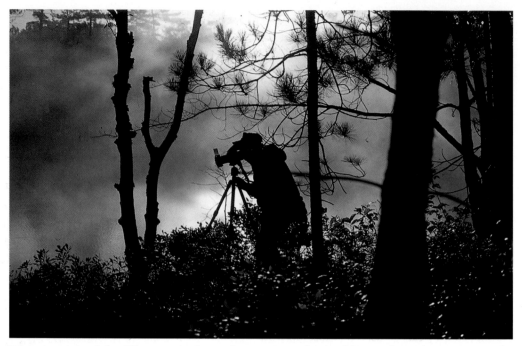

We use a tripod for 90 percent of our photos. A good tripod is nearly as important as the camera—it stabilizes the camera and slows us down so we can compose our scene carefully. (Photo by Zach Rowinski.)

we're not trying to hand-hold the equipment. Common wisdom says you can hand-hold a camera if the shutter speed is at least as high as the length of the lens you are using—for example, you can hand-hold a 125mm lens if you're shooting ¹⁄₁₂₅ second or faster. But if you have to shoot with that same lens at ¹⁄₆₀ second, you'll need a tripod to prevent blurriness due to camera wobble.

We have long thought that the real reason for the improvement in our images is that mounting the camera on the tripod forces us to take our time. We set up the shot better, we compose and focus better, we're probably more careful with the exposure, and we're more likely to bracket questionable lighting situations.

> *The single most important piece of equipment, after your camera and lens, is your tripod—it can improve every shot you take.*

Buy the sturdiest tripod you can afford that fits your weight requirements. We often travel with two tripods: one is a little lighter and can be packed easily; the other, our standard tripod, is heavier and more stable. We really prefer this heavy one and carry it on virtually all our trips. To make it easier to carry, we wrap the legs with insulating foam so it can sit atop our shoulders comfortably.

There are two major choices when it comes to tripod heads. **Pan/tilt heads** have separate handles for every direction of control. They provide precise movement of every camera direction, but tend to be heavier and more time-consuming to use. They're useful when you want to lock in one axis of adjustment while still being free to move the others. For example, you can position a precise vertical line, lock it in, but still have the freedom to swivel and tilt up or down.

The **ball-and-socket head** is lighter, more compact, and a little faster to use, because one handle moves the camera in all directions. This means that every time you loosen the handle, all movements are free. We generally prefer this option for fieldwork.

If you do close-up work, you'll need a tripod that works close to the ground. There are tripods with center posts that invert, so you can get the camera to ground level. But we've never gotten used to working upside down. Both our tripods collapse all the way to the ground, so they can be used for close-up work when we slip in a short center post. There are also a number of mini tripods on the market, and while we can see the advantage of using them, they've never given us the feeling of stability we want. But try one and see what you think.

For close-ups, find a tripod that works close to the ground. Some tripods have center posts that invert, but it's not easy to work upside down. Instead, look for a tripod that collapses all the way to the ground.

There are also other types of camera supports designed specifically for use with long telephoto lenses, which are great for sporting, action, and wildlife photography. You can buy shoulder gun stocks, or stocks that are supported on the chest. A simple monopod may be enough support in certain circumstances. See chapter 6 for more information on supports for wildlife photography.

FILTERS

Filters are glass disks that attach to the lens to absorb or modify the transmitted light as it enters the camera. There was a time when purist photographers refused to use any filters, believing that they should try to capture the essential light just as it appears, rather than correct it or enhance it in any way. And it's still true that special-effects filters or those that radically change the natural colors don't play a role in traditional nature photography.

But there's another category of filters that should be an essential part of every field outfit. These correct the light so that the film sees what you see, and help by bringing out rich colors or eliminating the glare from bright reflected sunlight.

Skylight Filters

Many people use **skylight** or **UV** filters religiously: skylight filters reduce the bluish cast on a bright day; UV filters supposedly reduce the effects of haze, although we prefer the results we get with a polarizing filter (see below). These filters are also recommended for protecting the

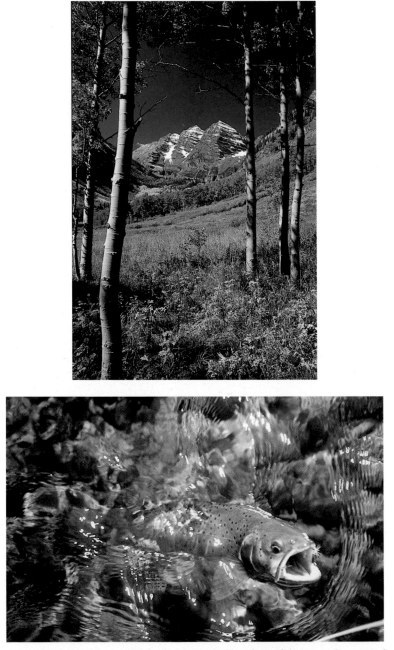

We often use a polarizing filter, which eliminates glare from foliage and water, darkens blue skies, and makes colors more vivid.

lens from scratches while you're in the field. But we generally prefer not to have these filters on our lenses: they just add an extra layer of glass that can get dirty or smudged. Keeping your lens cap handy seems a good enough way to care for your lens.

Polarizing Filters

On the other hand, the one filter we could not do without is the **polarizer,** which eliminates glare from reflective surfaces and reduces the effects of haze. Colors are more saturated—skies are bluer and grass is greener—because you have removed glare that your eye might not have even noticed. The polarizer works best when your camera is pointed at a right angle to the sun. Just attach the filter to the lens and rotate it until all unwanted reflections or glare are gone.

The one filter you cannot do without is the polarizer, which eliminates glare from reflective surfaces and reduces the effects of haze.

Warming Filters

Another filter you may want to keep with you is an amber-toned **warming filter,** designated for increasing strength by the terms "81A," "81B," or "81C." These are light-balancing filters

Using a warming filter such as an 81B helps balance cool colors in shady conditions or on overcast days. It also works well to balance bluish UV rays at high altitudes.

that adjust for the amount of blue and make colors a little warmer, and are excellent for shooting in shady areas that tend to be much cooler because of the higher percentage of blue light. If you only carry one, try the 81B: its midtone amber color covers most situations.

Neutral-Density Filters

Neutral-density (ND) filters control the amount of light that enters the camera, and are used when you want to slow shutter speeds or open the aperture. We especially like a graduated neutral-density filter, which is half skylight and half neutral-density; it allows us to give a landscape the exposure it needs for full saturation while toning down the sky a bit, so the intensity of the light doesn't burn out cloud detail.

MOTOR DRIVES

Motor drives advance your film automatically. Many of the new automatic cameras have built-in motor drives that can be adjusted to advance film from 1 frame per second to as

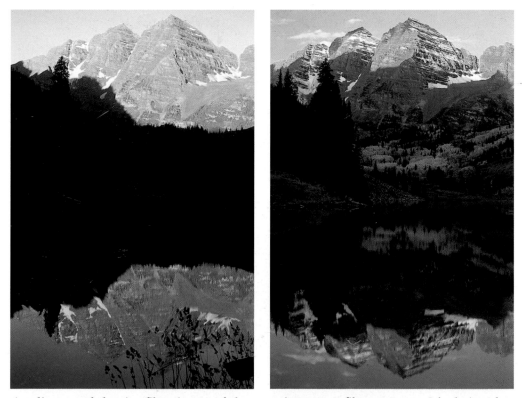

A split neutral-density filter is one of the most important filters we use. It's designed to bridge the gap between areas that are 1 to 3 stops different in exposure value. The split filter deepens the sky while leaving the landscape values intact.

much as 5 frames per second. If your camera doesn't have a built-in motor drive, it may be capable of accepting an external drive.

There are certainly times when this feature will come in handy—animal and sporting-event photography, particularly, are enhanced by the ability to move quickly. But if you're more interested in landscape photography or close-ups of flowers, you might consider skipping this option. For one thing, a motor drive makes the camera significantly bulkier. The other factor is that speedy film advance can make it easy to burn through a lot of film! Sure, there are rare moments when a burst of shots will help you capture the desired image, but there are many more circumstances when a shot or two would serve the same purpose. After all, even 5 frames per second isn't that fast when you're shooting at a shutter speed of ½₅₀ second. Be aware, too, that the motor drive can actually add complications if you're working in hot or cold extremes (see chapter 9 for more information about these conditions).

Inexpensive accessories such as cable shutter releases, extension tubes, and reflectors add versatility to your field outfit.

OTHER ACCESSORIES

There are a handful of other accessories that will round out your field outfit. The first is the **cable release,** a small push-lever cable that screws into your shutter release and allows you to squeeze off a shot without touching the camera. This prevents you from causing any accidental camera shake. These devices are inexpensive and very handy, particularly in close-up or low-light conditions.

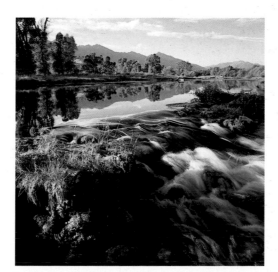

We wanted to render the water motion silky smooth, which required a 1-second exposure. Using a cable shutter release helped us eliminate camera shake on such a long exposure.

Here, we used a diffuser screen to soften the light and eliminate harsh spots. The diffuser we use has five interchangeable screens that diffuse, reflect, or block light, and it packs down into a small, portable package.

A set of **extension tubes** is an excellent and inexpensive way to get close-ups of your subjects. An extension tube is a hollow, fixed-length accessory that fits between your camera body and your lens; different lengths provide varying amounts of magnification. We find them to be the most cost-effective way to get sharp close-up images.

We don't go anywhere without a little set of **reflectors** and **diffusers.** There are a number of products on the market for bouncing a little light onto your subject, but we usually make our own easy-to-pack versions.

We also keep a **small flash** in our gear bag, just in case we need a little burst of light. We only use this flash if it's absolutely necessary, because bouncing a little reflected light creates a better, more natural effect. But every once in a while the flash comes in handy. See chapter 5 for more information on these and other close-up accessories.

CHAPTER 3

Composition and Perspective

G ood photographs don't come from fancy camera equipment, dramatic lighting equipment, or special effects. Photographs that stand out in terms of their ability to engage an audience's interest and imagination have one source: the vision of you, the photographer.

It is your eye that makes decisions on what you want to share with viewers of your work. Success is measured by what you decide to include in your photograph and what you eliminate, as well as by your choice of angles and lighting.

The most important thing you can do to improve your photography is to take the time to train your eye. We all see images every day that attract our attention. But have you ever stopped to ask yourself why a particular scene causes you to pause? What is it about the scene that makes it

> *The success of your photograph will be measured by what you decide to include as well as what you eliminate.*

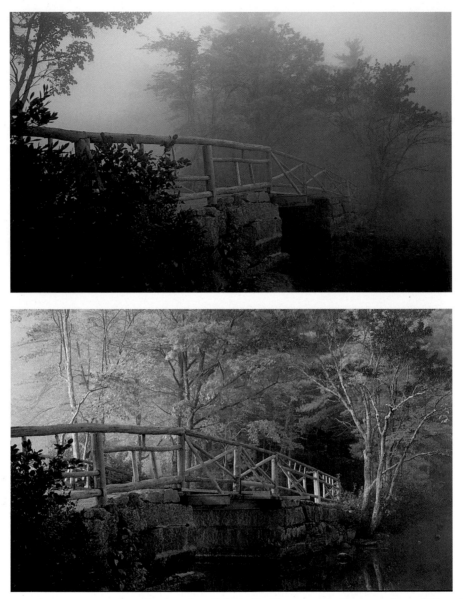

These two images were taken in morning light a few days apart. Compare how different the same scene looks in different light. Pick out places near your home and record them in changing seasons and light.

so special? To help train your eye, try to go by the same scene every day and take a close look at it. Is it special every day? Probably not. Find out why.

We find our blood starting to stir every fall. We itch to get out with our cameras, well before the colors of the trees start to change. Why? Because the angle of the light in autumn captures our imagination, and makes ordinary, everyday scenes glow in a way they don't the rest of the year. The low angle of the light brings out patterns and textures we don't see the

rest of the year. For you it may be another season—some photographers love the crisp intensity that only winter brings, for instance. Find out what kind of light inspires you, then determine what subjects most often draw your attention and concentrate on them.

When you're able to articulate your preferences and the reasons behind them, it's time to pick up your camera. Remember, while your eye and the camera's lens have a lot in common, the camera has certain powers that you don't. It can zoom in on details that your naked eye can't. It can home in on the frame of the image that interests you and block out everything else. Learn to use these powers to your advantage.

Of course, your camera also has certain limitations. While you have two eyes to take in a scene, the camera is limited to one. While your eye and mind can balance the details in highlight and shadow, you may find your camera and film unable to record these details as you perceive them with your eye. Understanding the limitations and strengths of your camera equipment and film are the first steps toward taking consistently better photographs.

IDENTIFYING YOUR SUBJECT

Every photographic situation provides you with an array of choices. Imagine that you're photographing Little League baseball players. Take in the whole scene first. What is capturing your attention—what is most important here? Is it a close-up of a child in rapt attention on the ball field, or the juxtaposition of team members against the backdrop of green grass? Or the intensity of the sideline parents? Look carefully. What do you see?

If you're doing a story on the team, all these scenes are important. You'll have to prepare a whole album to create a complete record of what went on that day. But you'll have to do it one shot at a time.

It's likewise out in the field. Autumn is always a real trap for the avid nature photographer—the colors are so spectacular that it's

When you take in a scene, ask yourself, "What is most important here?"

easy to just point into the forest and shoot. We have pages and pages of pretty-leaf pictures. Some of these shots have served a purpose as eye-catching background graphics. But many of them wouldn't be hung on the wall on their own. Why not? Because we forgot to ask ourselves what we were trying to accomplish.

Sit down in front of a wild forest of bright autumn colors and just look. What do you see? If you're patient, some specific subjects will start making themselves evident. Look at how the river scene glows with the reflection of autumn leaves and blue sky. Move closer to capture the birch trees reflected in the water. Crop in closer still to create an impressionistic painting of water and light. Now you're making progress; your eye is sorting out the details. Again, choosing what *not* to include in your picture is as important as choosing what to include.

Learning to see, to find images that express your view of the world and the passion you feel, takes practice and patience. This image popped out of the riot of fall color.

It takes time to develop your photographic eye. When you find a scene you like, work it from every angle and with different lenses. Many times you can improve on the image you originally noticed by letting your imagination take over.

After you've chosen your subject, the next step is to place it to its best advantage and turn it into a cohesive picture.

FORM AND LIGHT

Shapes alone do not make your subject: the form of your subject is governed by the light in which it is viewed. Shadows and highlights will bring out the visual attributes of an object that turn it from a mere flat form to an object with weight and depth. It's the light's variations in intensity, angle, and direction that give your subject impact.

Front lighting illuminates only the parts of the subject that are facing the camera, and is usually considered **normal lighting.** Because it imparts few shadows, it tends to create a fairly flat effect.

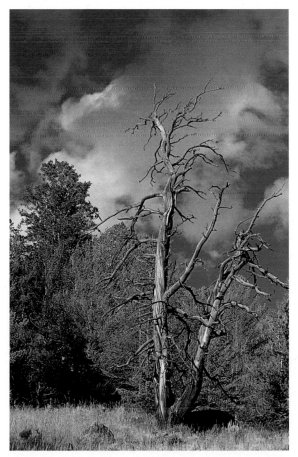

Front lighting can be very flat. Choosing an interesting subject will enhance your chance of capturing a good photo.

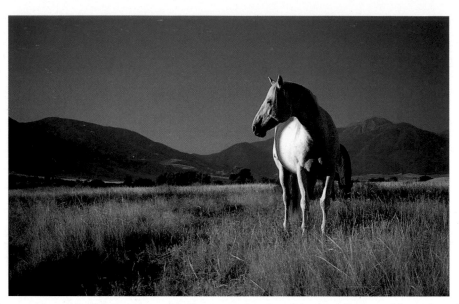

Early-morning side lighting gave this image contrast and texture that would not have been there during the afternoon.

Side lighting comes at the subject at a right angle to the camera. This lighting tends to bring out the full effects of texture and form. Morning and evening sunlight usually provide this kind of light.

Back lighting is certainly the trickiest to use. The camera is unable to capture the image exactly the way your eye sees it, because it cannot register the range of contrasts the same way

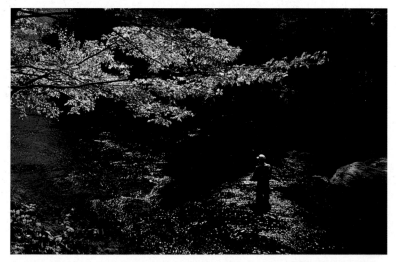

This is a dramatic photo, but back lighting such as this can be difficult to meter properly. We metered off some nearby grass to get an average reading, reframed, and shot the fisherman at that exposure.

your eye and mind can when working together. But it also has great potential for high impact, as with dramatic silhouettes.

The quality of the light will also have an effect on your subject. Bright, direct light will create hard shadows and reflections. Soft, diffused light will soften those edges and help bring out colors and patterns. Dappled light can be a benefit or a curse, depending on the subject. Watch how the light affects your subject, especially outdoors. Light is ever changing, and the alternating shadows and variations of tone will have an effect on your composition.

> *Light has direction. Determine whether front lighting, side lighting, or back lighting is most appropriate for your subject.*

PERSPECTIVE: CHOOSING YOUR VANTAGE POINT

Your eye perceives a subject based on its spatial relationship with its surroundings. From a distant vantage point, a mountain may look small and relatively near other objects in the scene. But when you drive down the valley and closer to the mountain, suddenly it becomes

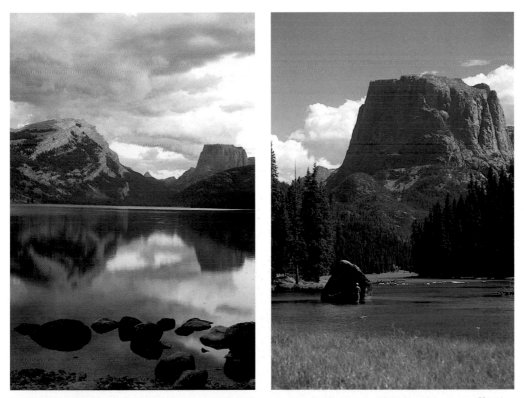

When you choose perspective, you are choosing the angle that you consider the most effective for capturing your subject. From a distant vantage point, a mountain may look small. When you approach it, suddenly the mountain dwarfs everything. Consider the impact of photographing your subject from different vantage points.

enormous, dwarfing everything else in its vicinity. The other mountains that seemed so near are now completely out of view.

> *Perspective is the interrelationship between a subject and its surroundings as seen from your vantage point.*

This is **perspective**—the interrelationship between a subject and its surroundings as it pertains to your vantage point. When you choose your perspective, you're choosing the angle that you consider most effective for capturing this particular subject.

Many photographers automatically take pictures from the vantage point that seems most natural to them, eye level. But consider the impact of shooting the same subject from a higher or lower perspective. Shooting up at the mountain will emphasize its majesty and may isolate it from its surroundings against a background of brilliant blue sky. On the other hand, climbing higher and shooting down on it reduces its significance, showing it as just one of many peaks in a range. This is your perspective.

After you've chosen your vantage point, select the lens that will allow you to include only as much of the scene as you want. Use a wide-angle lens to take in much of the area; use a

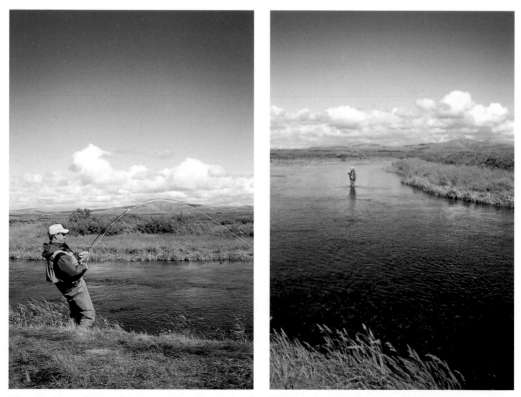

Shooting at eye level focuses the viewer on the fisherman. Moving to a higher vantage point diminishes his importance in the scene.

telephoto lens to home in on one aspect of the scene. Remember: you haven't changed your perspective, you've only changed how much of the scene you wish to share.

Changing your lens does not change your perspective, it only changes how much of the scene you wish to capture.

THE RULE OF THIRDS: SUBJECT PLACEMENT

There are no hard-and-fast rules regarding composition, but there are a few guidelines that may help you decide where your subject should be placed in relationship to the rest of the scene. One of these guidelines is called **The Rule of Thirds:** divide the image into thirds vertically, and then again into thirds horizontally. The intersections of these lines are all strong areas in the frame. If there's more than one element in the image, placing your main subject off center where the lines intersect can make the composition more balanced and pleasing to the eye.

If, on the other hand, you're dealing with a single element of interest, the most effective placement of the object will be closer to center. Faces are a good example. The upper third of the head should be in the upper third of the box. The Rule of Thirds helps you avoid the amateur photographer's curse: the bull's-eye shot, in which the head is placed dead center.

There are occasions, of course, when absolute symmetry is called for. These subjects are best placed in the center position.

If you're shooting animals or people, always make certain they're looking *into* the frame—give them some space in the direction they are looking, to give the image a logical framework. If

The Rule of Thirds can help you decide where your subject should be placed in relationship to the rest of the scene.

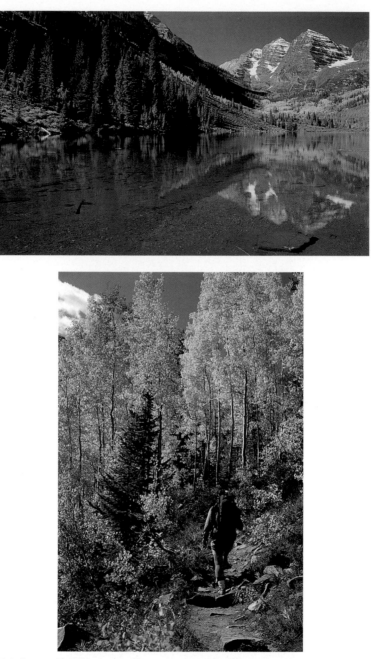

The Rule of Thirds, applied horizontally and vertically: the mountain is positioned in the upper third of the photo, and the hiker is positioned in the lower right third of the frame, walking into the photo.

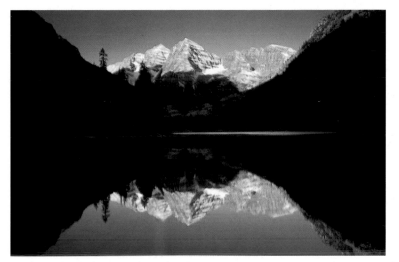

Rules are made to be broken: sometimes landscape reflections are most dramatic when they're perfectly centered!

Always position your subject looking or moving into the frame, which also pulls the viewer into the photo.

your subject is looking out of the frame, you'll lose any sense of the subject's involvement with its environment.

> *Converging lines create very strong intersection points and can be a powerful way to draw the eye where you want it to go.*

THE POWER OF LINES, TEXTURE, AND REPETITION

Another important way to create images with impact is to use lines to lead the eye to the subject: hard lines can be used to suggest motion, aggression, restlessness; soft, rounded lines might suggest a gentle, calming atmosphere. Lines can be absolute, such as horizons, trees, or fence posts, or they can be suggested, as a series of rocks, flowers, or even shadows that draw the eye to the main subject. Converging lines create very strong intersection points and can be a powerful way to lead the eye.

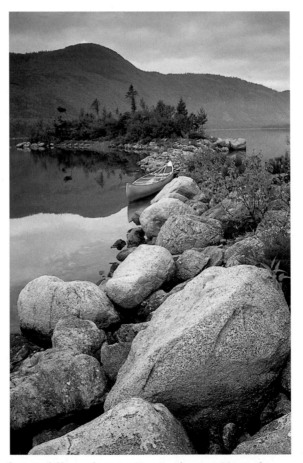

The sensuousness of curved lines always attracts the eye. Here, the round boulders and the curving lakeshore combine to give the image depth and entice the viewer into the photograph.

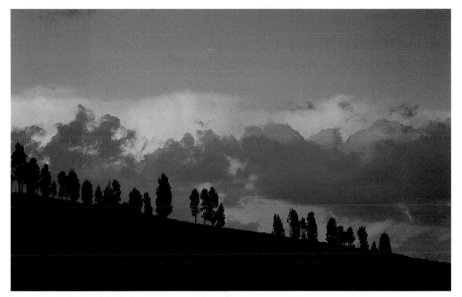

This angled skyline creates tension in the image, and makes it more dramatic than a straight horizontal skyline.

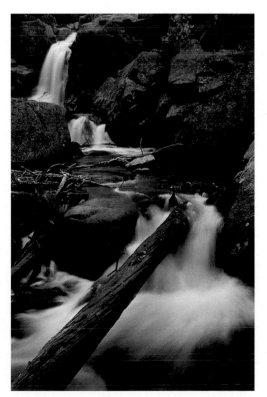

We positioned the log in the foreground to visually pull you into the photo, leading you up the stream to the waterfall.

Be aware that strong lines can also inadvertently draw the eye away—for example, a horizon line to which you paid no attention when you composed your shot might cut the image in half and destroy the composition for which you were striving. The best way to test your image for proper line definition is the squint test: look at the scene with your eyes slightly squinted. What stands out? You'll notice the strong lines that are the backbone of the image.

The myriad patterns in nature can also make very strong visual images. If you're looking for harmonious repetition, avoid anything that might interrupt the flow of the pattern. When you locate a theme or repetitive pattern that interests you, try to isolate it from the rest of its environment.

Eliminate any distracting elements and find the angle of light that maximizes the effect. A low angle of light will often bring out shapes and details that full sun would eliminate. Repetitive patterns in nature can create images with a lot of impact.

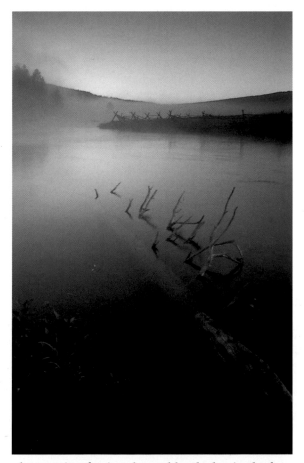

The eeriness of an early-morning fog is enhanced by the log in the foreground, which draws you into the image before disappearing in the mist.

We are constantly on the lookout for the myriad patterns found in the world around us. These dead white branches create a startling contrast to the autumn red of the blueberry leaves.

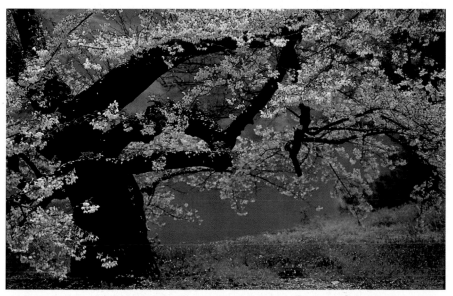

This cherry tree, found on an overcast day in Japan, was beautiful. We walked around it until we found a composition that highlighted the sweet-looking cherry leaves against the stark, wet, black bark.

One of our favorite times to look for patterns in nature is early fall. The first frosts turn morning foliage into magical images.

FORMAT

A horizontal format tends to have a peaceful, harmonizing effect on the subject, while a vertical format connotes a greater sense of energy.

Horizontal or vertical? Since most of us photographers shoot at least a proportion of photographs with a 35mm camera, we're generally working with a rectangular format. And because of the way most cameras are built, we find it very easy to shoot most of our images horizontally. Horizontal photographs are perfectly suited to the nature photographer, and are often referred to as **landscape format,** which tends to have a peaceful, harmonizing effect on the subject. On the other hand, vertical formats, often referred to as **portrait format,** tend to connote a greater sense of energy.

A mountain scene in a horizontal format may seem almost pastoral. Turn it to a vertical, and suddenly the sense of energy and majesty increases considerably. A horizontal portrait, on the other hand, may seem more casual and relaxed. So experiment! Shoot images both ways to see which gets you the most impact. Also consider the ultimate use of your images. Professional photographers often make certain they end up with images that go both ways: horizontals are great for wall calendars, while most magazine covers are vertical.

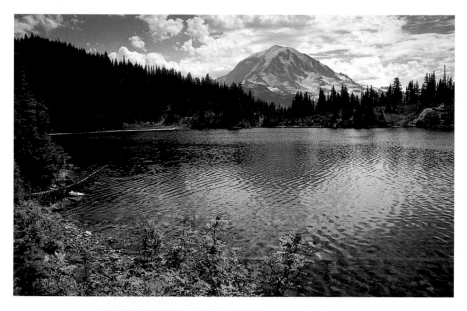

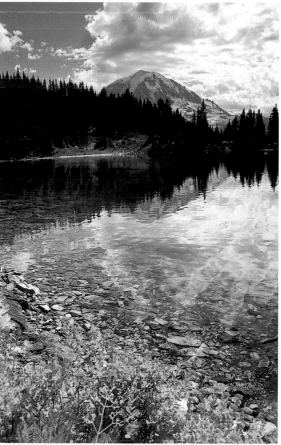

The mountain scene in a horizontal format seems peaceful. Switch it to a vertical and you get a greater sense of energy and majesty.

CHAPTER 4

The Landscape

There are few things more joyful to us than the thrill of photographing the landscape, and because it's so accessible and so abundant, we're never in short supply of subject matter. The best part, of course, is that the light is never the same twice: we can visit the same area at the same time every day and never get exactly the same picture—even subtle shifts can produce dramatically different results.

But good landscape photography is not as simple as it seems. The trick is learning how to find the key elements of a scene that will make your pictures sing. You must teach your eye to evaluate an enormous set of possibilities, then translate the scene into a photographic image that will convey all the depth, scope, and drama of the image.

There are a number of techniques that can help you avoid many of the mistakes that are made by the average point-and-shoot photographer.

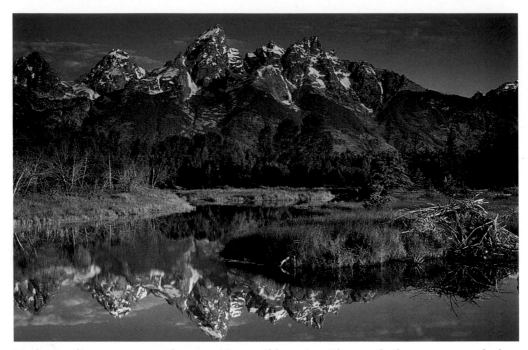

Understanding exposure and composition, and knowing where and when to capture the best light, are the key ingredients to successful landscape photography. Grand Teton National Park, first light: f16 at ½ second, Fuji Velvia 50 film.

BASIC LANDSCAPE DESIGN

Simplify, Simplify, Simplify

If there's one thing that we try to get across to students in our photographic classes, it's this: simplify! In nature it's so easy to get lost in the clutter. The landscape as the eye sees it is dramatic, pleasing, harmonious. But the camera is more discriminating. It will capture for eternity the exact moment of the place, and along with this come all the quirks, wrinkles, and clutter.

This is why you need to be very clear about what you intend to photograph. Know your subject before you begin. If you have to sit and stare awhile before picking up your camera, then do it. Make a frame with your fingers like the old-time movie directors did, and pan the scene. For example, let's look at a mountain scene: the mountain is there, of course. There are some trees in the foreground; the sky is spectacular. There's a cabin off to the side. There's a fence, a couple of horses. Oh, and if you look a little closer, there are some low bushes, a dip in the landscape where a stream cuts through . . .

Sure, it all looks great together: the epitome of the American West. But shoot it exactly as you see it, and what happens? The horses look like ants, the dip of the stream becomes a

One of the most striking things you'll learn by studying the master photographers is that their most effective photos are simple, clean, and crisp. Simplify! Eliminate the clutter.

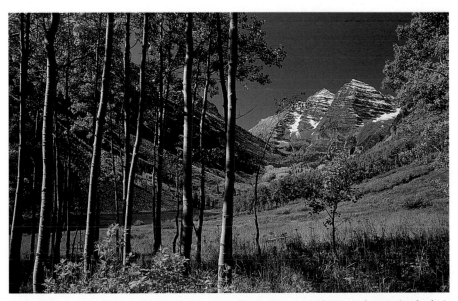

One of the most rewarding aspects of photography is that you choose what to include in your photos and what to eliminate. How you compose these elements defines your individual style.

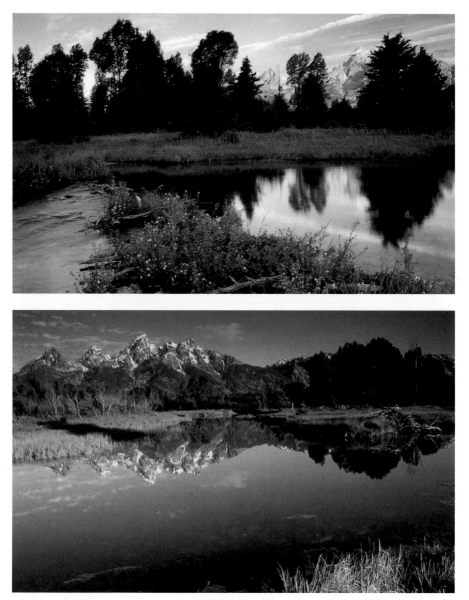

Be careful to include in your photos only those elements that are essential to make the composition express what you see and feel. Eliminate anything that takes away from the main subject or theme.

strong horizontal line across the bottom that doesn't make sense to the eye, the trees are close and out of focus . . . there are so many ways to get this shot wrong that we can't enumerate them all.

So think about this scene some more. What's the point you're trying to make? Do you want to capture the spirit of the American West? Then maybe place that cabin in the foreground as

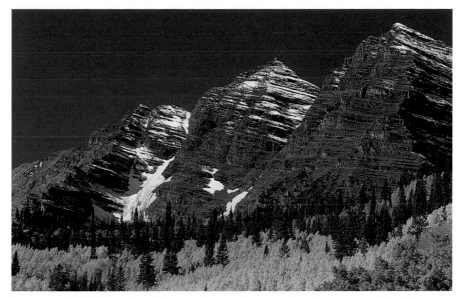

Experiment with different-focal-length lenses for your landscapes. In this shot we used a 300mm lens to isolate the mountain and emphasize its size and majesty.

the main subject, with a backdrop of the mountain. Are you trying to suggest the majesty of the wilderness? Then maybe isolate the mountain and sky. Tackle the scene any way you wish, but know what your goals are first. In landscape photography, less is always more!

> *In landscape photography, less is always more. Know your goals before you shoot.*

Illustrating Scope

Traditionally, the sheer magnitude of a scene has been captured with a wide-angle lens. But panoramic images have become increasingly popular in recent years. While this new format can be very appealing, it would be a mistake to think that it solves all the problems of capturing the drama of the landscape. Whether you're using a normal lens, a wide-angle lens, or a camera with panoramic capabilities, the problems of composing a panorama of the landscape remain the same.

To evoke the openness of the landscape, compose your photo with an emphasis on the distant horizon. Using the Rule of Thirds, place the transition from earth to sky on one of the two horizontal planes. If there's a mountain peak or lone tree, try placing it off center one way or the other. A billow of clouds can also be placed in this manner. To emphasize a sense of space, keep the amount of foreground in the shot to a minimum.

Try various vantage points. Shooting down on the scene may emphasize the harmony of the environment. Shooting up at it may intensify its impact.

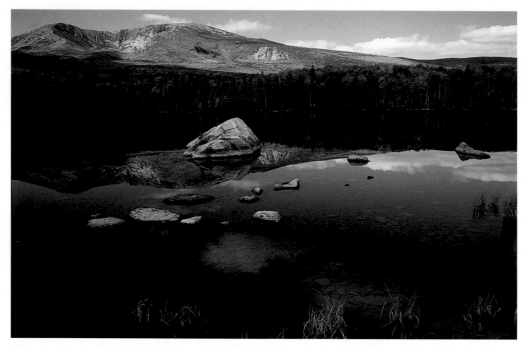

This is a more classic landscape using a 28mm lens, with the camera mounted on a tripod. The small aperture setting of f32 gives enough depth of field to bring everything into focus.

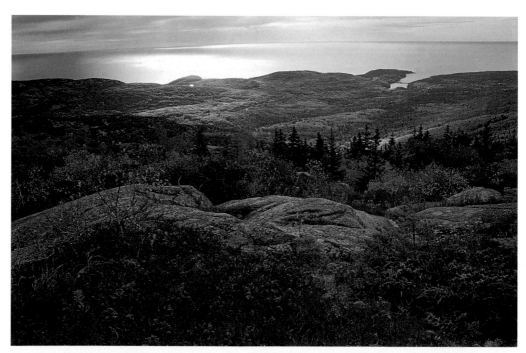

Shooting down on this scene minimizes the effect of the many hills and valleys. It creates harmony in a very rugged landscape.

Illustrating Depth

To illustrate scope, try to maximize the impact of the expanse of land *across* the camera's plane. To illustrate depth, your goal is to display the expanse of land that stretches *away* from the camera. You do this by choosing a foreground feature as your primary subject.

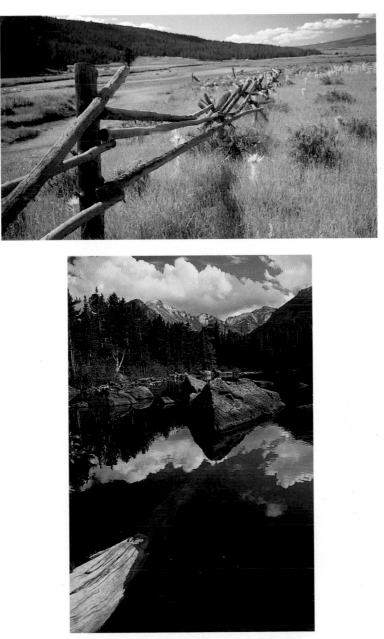

In both photographs we use the foreground to add tension to the image and pull the viewer into the scene. Both were taken with a 28mm lens and a small aperture to ensure good depth of field.

> *To illustrate scope, maximize the impact of the expanse of land across the camera's plane. To illustrate depth, capture the expanse of land that stretches away from the camera.*

The foreground adds tension to the image and helps connect viewers to the photograph immediately, by drawing them into the scene and beyond to experience the complete environment.

To best illustrate depth, you should shoot a scene for maximum depth of field: your aim is sharp focus from foreground to background. This can be difficult to achieve, and often means shooting with a very small aperture, f16 or f22. If there's even a gust of wind, the recommended shutter speed may be lower than you can reasonably use with this small aperture setting. If this is the case, open up to the required f-stop and let the far background go into soft focus.

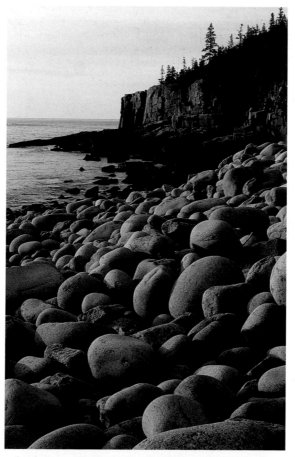

This simple photograph of Otter Cliffs in Acadia National Park isn't as simple to capture as it seems. You have to be there and set up before sunrise. Once the sun is up, you only have a few minutes when sky, water, and cliff are in perfect balance. Knowing your subject is one of the keys to consistently successful landscape photography.

But don't let the foreground image lose its sharpness; if you can't get the foreground sharp, try another lens or change the camera's position. Sharpness is everything in this type of shot. If you can't get it, don't shoot.

And don't forget to experiment with the differences between the vertical and the horizontal format. Often the solution to your design problem becomes obvious with the turn of the camera.

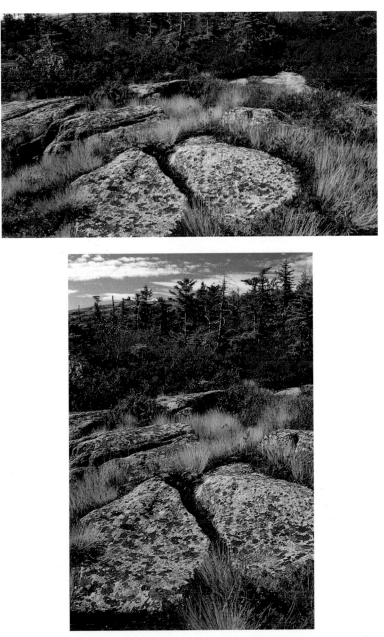

Experiment with horizontal and vertical formats. Often the solution to your design problem will become obvious with the turn of your camera, so shoot both.

THE EVER-CHANGING LIGHT

Light changes constantly. Be aware of how light shifts in color, angle, and intensity as the day progresses.

Natural light is an amazing thing—it changes hour to hour, day to day, and month to month. The light's **color** changes throughout the day, starting warm in the morning, turning blue as the afternoon progresses, and turning back to warm before darkness creeps in. The **angle** of light changes too: daily changes are obvious, of course, but seasonal effects give us some of our most spectacular moments. The **intensity** of light also has a great impact: pictures recorded at noon on a brilliant day will have a very different mood from those shot in the same place on a cloudy day. Light tends to bounce off other things, too, and this **reflected** light can cause glare and harsh hot spots on film, or it can be harnessed to fill in shadows.

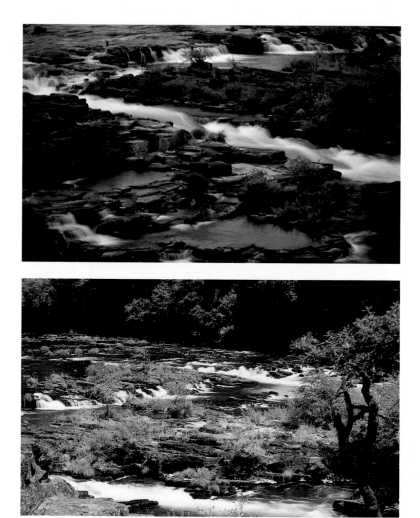

Light is constantly changing. Sometimes it's hard to believe the difference between first light and the light a few hours later at midmorning.

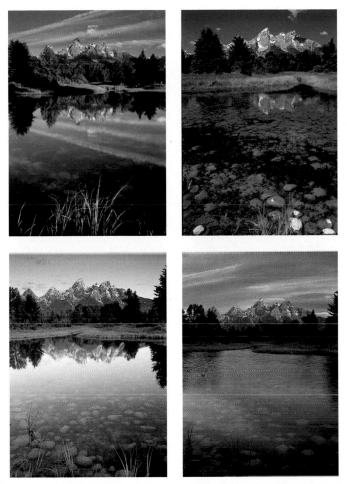

This scene of the Tetons is one we've seen many times, but every time we're here, it has a different face with different light.

Pick a scene you like, maybe one you travel by often on your way to work. Every day, look at what the light is doing. When it sparkles, note the month. When it glows, note the time of day. If you have a minute, stop and look closer. Ask yourself what it is about the quality of the light that draws your attention. Do you love its mellow mood? Or are you drawn to its vivid intensity? Light can change any scene into something completely different. We're always surprised when someone says to us, "Oh yes, I've already shot that. I was there two years ago." Wow! That scene has been through thousands of variations since then. Nature shows us its many moods every day. What you do with these moods is up to you.

The Edge of Light

Early morning and late evening are the witching hours of landscape photography. Scenes that you walked by all day suddenly begin to glow; clouds shimmer in warm tones of yellow and red; silhouettes spring to life.

Ordinary scenes—this one is just outside our door—can turn to magic when the light is just right. The right light and a tight composition created a wonderful image.

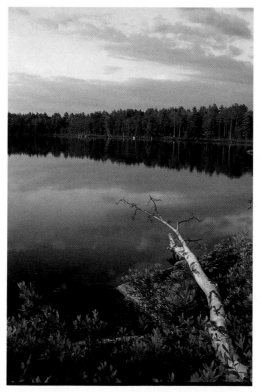

We seldom photograph landscapes during the middle hours of the day. We spend our time scouting for locations that will help us maximize the light during the few hours around sunrise and sunset.

You have to be ready when the light begins to change and shift—colors come and go quickly. When we're traveling, we scope out a new area during the day so we're ready when these magic light shows begin: we determine where the sun is likely to rise and set; we note likely subjects and backgrounds. Then, about half an hour before we think the light is going to change, we set up our tripods and wait. If we're spending a few days in the field, we note the successes and trials of that first day so we can alter our plans for the next day.

> *When you expect spectacular light, plan ahead: know where you're going to shoot so that you're ready when the light starts to change.*

Weather

Along with the time of day, weather can play a huge role in creating memorable, moody images. A foggy morning or a rainy afternoon turn the landscape into a distinctly intimate environment. When the sun peeks through and reflects off these damp surfaces, a riot of possibilities occur. And we couldn't live without storms. We're always on the lookout for a buildup of cloud banks for creating moody images or adding some intensity to a special scene. See chapter 8 for further discussion of wild sky conditions.

SPECIAL PLACES

Over the years we've traveled quite a bit, and we've encountered lots of situations where we said, "If only we knew such-and-such about this place, we could have come another time or stopped at another vantage point or brought a different piece of equipment." Before taking a

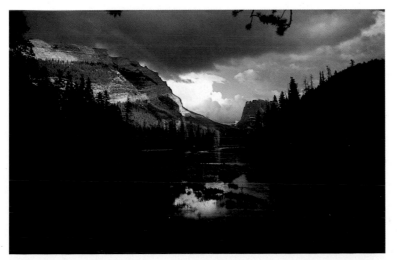

This is one of our earliest images, and it inspired us to pursue outdoor photography. Working the edge of a storm in the hope of finding dramatic light can be frustrating and tremendously rewarding.

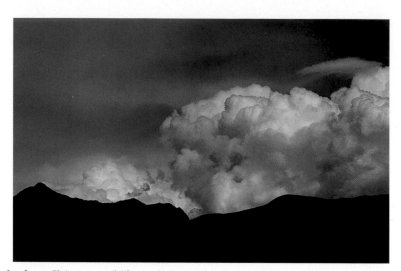

Cloud banks foretell intense shifts in light and color, and also produce interesting patterns. We exposed to maximize the impact of the cloud and let the mountain go into silhouette.

trip, plan ahead to avoid disappointment: know what kinds of conditions you might encounter, and be prepared. We usually call the National Park Service in the state to which we're traveling for information on things such as peak foliage and wildflower blooms. Travel guides give us ideas about our routes and the best time to travel in certain areas.

Mountains

Mountains love the light of early morning and late afternoon, when the sun kisses the tops of ridges and brings out the best they have to offer. Mountains create a dramatic silhouette when

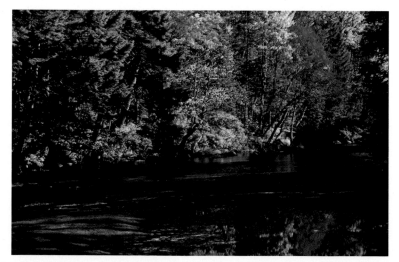

Call ahead to find out when peak foliage is expected in the area to which you're traveling. It can vary from year to year by up to a week.

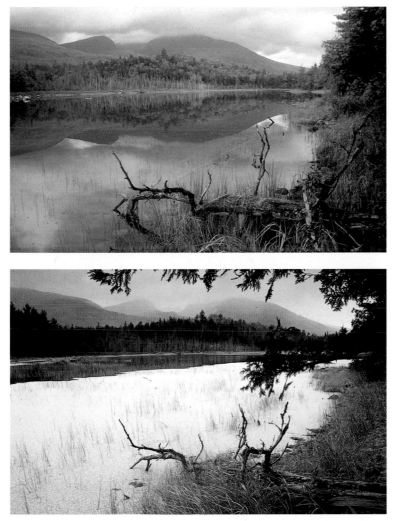

Photograph in all seasons and go back to the places that attract you. You can photograph the same scene a thousand times and it will be different every time—changing light and seasons make everything new.

they're backlit by a rising or setting sun. Add some foreground to give your picture depth, and use the Rule of Thirds when you place your horizon.

Remember that the snow flies earlier in the mountains, so any trip to high elevations should be planned with the knowledge that passes can close suddenly and storms can appear out of nowhere. We have actually been prevented from crossing a pass in mid-July! Call ahead to find out conditions of any major passes you intend to cross on your travels.

Canyons

We have sometimes found ourselves in canyons too early in the morning: light that's playing havoc with the surrounding ridges often doesn't make its way onto the canyon walls until

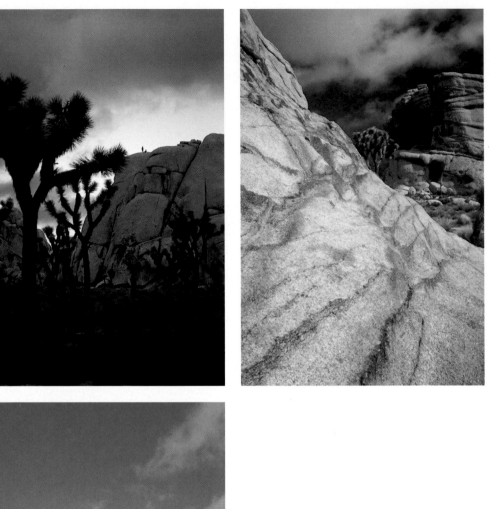

Canyons pose a problem in that there may be only a few hours of good light in which to photograph. In the upper-left-hand photo the light has not fully reached into the canyon; in the upper right the light is at the perfect angle and it can be beautiful; by the bottom left image the light is streaming in, and it's too bright and flat to evoke good images.

later. Before that moment the canyon is dark and flat, and after the sun rises enough to stream directly in, the light is hot and shadowless. But oh, that moment between! It's definitely worth getting up and waiting for. The sun reaches over the walls and angles into the canyon and suddenly brown cliffs shimmer with a reddish glow. Shoot up at the walls and accentuate their colors with a slice of brilliant blue sky at the top of the frame.

Canyons seem to have their own weather: very chilly mornings are often followed by scorching afternoons. Be prepared for all sorts of weather.

Seascapes

Anchor the image with an interesting subject in the foreground: a sailboat, a lighthouse, even an old lobster trap can give the scene depth and a sense of place; position them off center to create a pleasing image. Morning and evening are great times to shoot on the ocean, but watch for brewing storm clouds that could turn a serene day into a dramatic one. Always shoot with a polarizing lens to eliminate the glare on the water. And be careful to keep the horizon straight! A sloping horizon creates a very disconcerting image for the viewer.

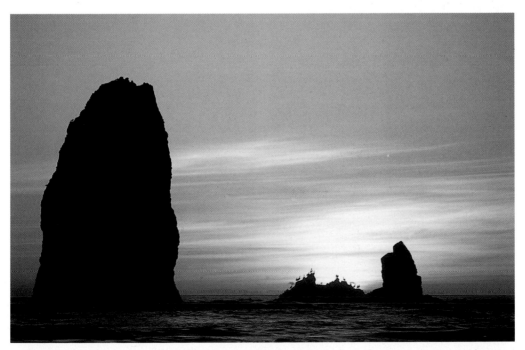

Anchor your seascape with an interesting focal point, such as these stone outcroppings.

Moving Water

Overcast days are a great time to shoot around streams and waterfalls. The soft light brings out the intensity of the colors and keeps the reflections softer and more subdued. You'll need your polarizing filter to control glare.

Experiment with different shutter speeds when you shoot around moving water: make a stream smooth and silky by shooting at ½ second, or catch every bump and ripple by shooting at ½₅₀. Try running a whole series of shutter speeds at one location. You'll be pleasantly surprised at the variety of interesting effects.

If you're going to hike in to a special waterfall, ask a ranger when to expect the best light. Many waterfalls are in deep forests, where they get a lot of shade. Sometimes midday is the only time they're properly illuminated. Again, play with shutter speeds to create different effects.

Deep Forests

Because the treetops create a heavy canopy, the deep forest has an environment distinctly its own. It's a world of green, and for us, the more intense and mistier, the better. Textures and colors are intense at midday, when the light is strongest. When you're hiking through deep

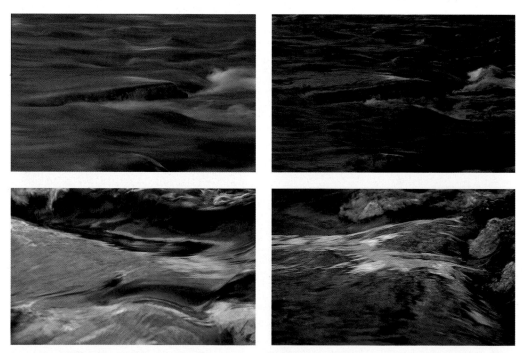

By using different combinations of aperture and shutter speed, we can make the water soft or hard edged, blend the colors together or keep them separate. Turning reflected-water photographs into genuine watercolor art is limited only by your imagination.

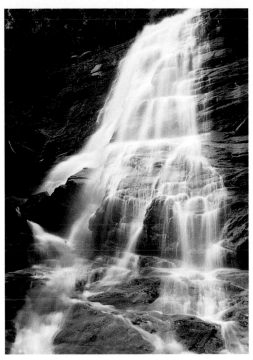

This waterfall is lit by the sun for only a brief time every day and it's a mile hike to reach. Before you take a long hike, ask rangers when the best light is available. A 1-second exposure at f32 made the water silky smooth.

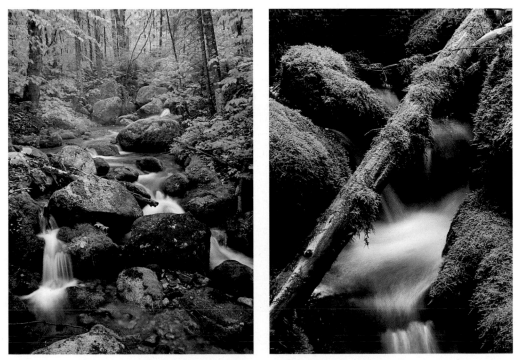

In contrast to popular belief, overcast days are great for photography. Light is even, balanced, and soft, and colors are intense and rich. We look for intimate or close-up photo opportunities on these days.

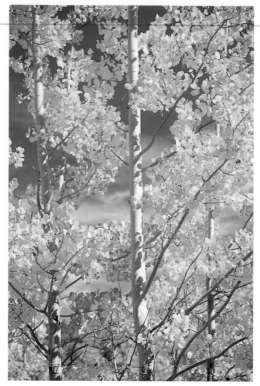

Look for images that combine complementary colors: aspens, Rocky Mountain National Park, Colorado.

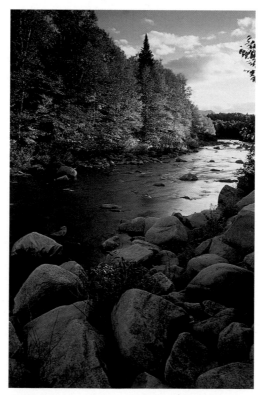

Fall color and the low-angle light of the season can change the ordinary into something memorable.

forest, look for moments of high contrast: the rich brown of a tree trunk against a wall of green; the intense yellow of a mushroom emerging from a rotted stump. Look up to see slivers of brilliant blue behind clouds of green leaves. Take along a small reflector to help bounce light onto shadowed subjects.

> *Every place has its magic—know a little bit about your surroundings so you can be prepared for conditions.*

Fall Foliage

A swirl of vivid autumn colors is often so intense that it's tempting to just point and shoot. Avoid this impulse, and instead study the forest for subjects that can anchor your image. Look for simplicity of line and form amid the sea of color to achieve a shot that's really memorable. A dark branch against yellow leaves, brilliant white birch bark in a sea of red and orange, or a sliver of blue sky framing a solitary maple tree all offer tantalizing possibilities.

You can find spectacular autumn foliage in many places across the country. Though we are partial to our New England leaf season, we have often traveled to Colorado to catch those intense yellow aspens against the brilliant mountain skies. You can call the National Park Service or your state's forest service to get recreational information. Some state governments even have 800-number hotlines to keep you up to date on foliage changes.

CHAPTER 5

Close-Up Photography

C lose-up photography allows you to explore worlds you might normally overlook on hikes through a forest or meadow. There are literally thousands of subjects to be found on the ground, in the forest canopy, or along lakeshores and streams. Wild-flowers, of course, are one of the most common subjects for close-up photography. But insects, tree bark, leaves, even pebbles become wonderful subjects for the alert photographer.

The special appeal of close-up photography is its potential to amaze and delight viewers. A raindrop on a leaf becomes an entire universe. The intricacy of a butterfly's wing captures the complexity of the natural world. And the delicate petals of a flower filtering sunlight illustrate how fragile and exquisite the ecosystem really is.

Close-up photography offers an amazing array of worlds from which to choose, and an endless choice of subject matter. If you already have a camera with interchangeable lenses, you can get started by adding just a couple of accessories.

EQUIPMENT

To get up-close and personal with your subject, you need the help of an **extension tube,** a hollow, fixed-length accessory that fits between your camera body and your lens; different lengths provide varying amounts of magnification. A normal 50mm lens will shoot a subject at about half of life size. ("Life size" refers to the relationship between the area that you're photographing and the size of the film format.) To get the subject to life size, add an extension tube approximately half the length of the 50mm lens—a 25mm tube. To get good close-up shots, the extension tube is an inexpensive and valuable accessory.

A **bellows extension** is also available for 35mm cameras and takes the place of extension tubes: it adjusts to different lengths so you can increase or decrease magnification without changing accessories. Make sure that the bellows you choose is designed to link up with your lens, or you could lose your ability to use **through-the-lens (TTL)** metering.

Macro lenses are essentially normal lenses that have a built-in extension tube, and are great for close-up work. Their main advantage is for *extreme* close-ups that require virtually no distortion, such as photographs of postage stamps or other flat specimens.

Screw-on close-up filters are an inexpensive alternative to both extension tubes and macro lenses. They function like little magnifying glasses, bringing small images up close for

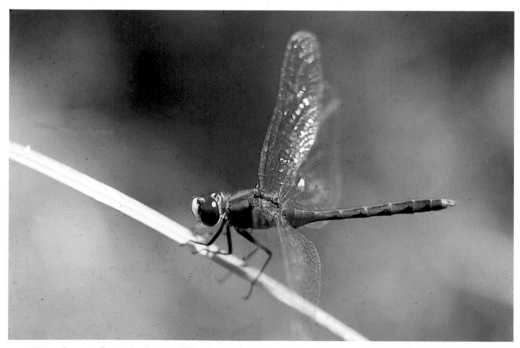

This dragonfly was shot at life size using a 25mm extension tube with a 50mm lens.

A 50mm macro lens let us into this puffball's world. A cardboard barrier eliminated any fluttering. A tripod and cable release prevented camera shake.

better viewing. But we don't recommend shooting with them, because they rarely produce a good, sharp shot.

You'll find that a **tripod** is essential if you do much close-up photography. Camera shake is a major problem with this delicate work, and a tripod is usually needed to provide stability. Mini tripods are designed specifically to get you as close to the ground as possible. They're lightweight, they're easy to pack, and they give you that extra bit of stability. Some full-sized tripods also have legs that can be spread out to bring you to ground level, or reversible center posts that let you place your camera upside down and near the ground.

Once your camera is on the tripod, another handy gadget is the **cable shutter release.** It allows you to stand back from your work a little, and prevents you from causing the camera movement that might occur if you used your finger to press the shutter release. A camera with a **built-in self-timer** can also be used for stationary subjects.

When shooting subjects that aren't going to move, use your camera's **mirror lockup** option if you have it. The mirror inside the camera is used to view the subject and get it into focus. But you don't need it down to take the picture. So just before you shoot, lock it out of the way. This helps prevent the slight jarring of the camera caused by the mirror snapping up and down.

There are many other accessories available to the close-up field photographer, and together they can create the equivalent of a miniature photo studio in the field. Lighting accessories such as reflectors, diffusers, and lighting units are covered later in this chapter.

Our daughter Jen spotted this little spider, which has the ability to change colors to suit his environment.

A good outfit for close-up photography includes a 35mm camera with 50mm lens, tripod, cable release, 100mm telephoto lens, extension tubes, and portable reflectors and diffusers.

With all this gear, you may find it handy to bring along a field assistant, and children love close-up photography. It gives them opportunities to explore microcosms and search out miniature miracles. We often take our children into the field and provide them with magnifying glasses. They serve as our advance crew, exploring areas we might miss. Of course, they can be a little disruptive to your moving subjects. On the other hand, they're often the ones who find the spiderweb, the field mouse, or the tree frog!

COMPOSITION

The key to a great close-up picture is *planning*. Small subjects can be easily overwhelmed by uneven lighting, cluttered backgrounds, and competing subject material in the viewfinder. That's why taking a few minutes to decide exactly what you want your photograph to include, and what elements should be omitted, can make all the difference.

We find that one of the surest ways to compose a good close-up photo is to put the camera on a tripod. Setting up your shot with the help of a tripod allows you to slow down and really evaluate the subject and its environment. You can walk away for a moment, view the subject from another angle, and stand back to see the surroundings. Being free to stand away provides us a little more time to think through what we're trying to accomplish.

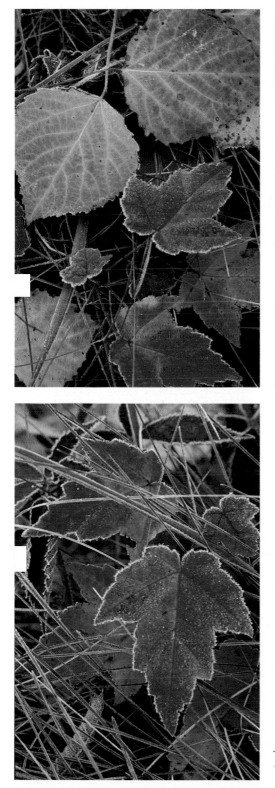

On the forest floor there are many possibilities. The upper-left shot has appealing colors, but there is no clear subject. The upper-right shot is better: we've chosen the subject, but there's still too much going on in the frame. The bottom-left shot is the charm: the leaves' frosty edges against the backdrop of grass gave us a crisp, clean, and simple image that has real impact.

Be aware of your subject's surroundings: check for cluttered backgrounds, uniformity of lighting, and contrasts in color and texture.

Do you want to show the extraordinary detail of one flower, or do you want the impact of an entire bed of flowers? Is the bumblebee your focus, or is it his relationship to the flower you want to capture? Look closely and make decisions before you click the shutter.

Evaluate the backgrounds available to your subject: a pale object will have more impact against a dark background, and a dark object will be enhanced if you can frame it against a light background. Often a change in camera position will help you achieve a strikingly different effect.

Uniform clutter, such as a bed of leaves, may make an acceptable background, but a branch running through the shot can be very distracting. Similarly, out-of-focus greenery might be just the right backdrop, but a sliver of blue sky peeking through the leaves can draw the eye away from your subject. Make sure there are no distracting elements or contrasting light patterns at the edges of your frame.

This bright yellow flower has more impact against a dark or blackened background. Move around the flower to find the best angle and background. Here, we used a piece of cardboard to block the sun and throw the background into deep shadow.

We knew there was a potential photo lurking in this thorny crab apple tree. We worked various angles and made a few different images, such as the one on top. Once the bottom image came into view, we knew we'd found what we were looking for. We adjusted the shutter speed and aperture to keep the thorns and crab apples in sharp focus and made the background of sky and yellow leaves soft and out of focus to accentuate the sharp thorns: exposure of ⅛₂₅ at f2.8 with a 105mm lens.

What about the shot that would be perfect if only . . . the branch were gone, the grass weren't so high, or the frog were on the rock instead of the log? Is it okay to manipulate the environment to get a great shot?

Our answer is *sometimes.* We have used tweezers to eliminate pine needles from an otherwise pristine bed of moss, and have held branches aside to get an unobstructed view of a mushroom. Often a shot is almost perfect, except for some small, distracting detail. These are reasonable ways to enhance your photograph.

We love frosty early-fall mornings: 105mm micro lens, ½ second at f16.

This spiderweb image would have been better if we'd controlled the background clutter by throwing it into shadow or more out of focus. We also should have eliminated the sky in the upper half of the background by moving our camera angle another foot higher.

A word of caution, though: some photographers, in their enthusiasm to capture a subject, can do serious damage to that subject's environment. Broken branches, upset birds' nests, and trampled flower beds are not the legacy you want to leave behind from a day of photography. So be aware of your impact on these tiny ecosystems.

DEPTH OF FIELD

You can't create a great close-up photograph unless your subject is in good, sharp focus. Unfortunately, it's difficult to make everything in a close-up sharp —as magnification increases, depth of field decreases. Small f-stops may seem like an answer to increasing the area of focus, but the light available in the field may not be sufficient. In addition, the necessary lower shutter speed often isn't practical, even for stationary subjects that may be at the whim of breezes. That's why the setup of your shot is so crucial to its success.

First, choose the plane of the subject that's most important to your composition. Is it the flower's outside edge, or the opening petals? The top of the mushroom, or its length? The cluster of

> *To create a sharp image, line up your camera so that the film's plane is precisely parallel to the most important part of your subject.*

Sharp focus on the dewdrops was our goal. We let the rest of the frame fall softly out of focus.

Crisp focus was ensured by placing the camera precisely parallel to the ground cover. Overcast lighting is best for this type of image, because it provides soft, even, balanced light.

To make focusing on your tiny subject easier, turn the focusing ring to the closest focal length, then move your camera back and forth until you find the ideal distance.

berries, or the thorns along its branch? Using a tripod, line up your camera so that the film plane is precisely parallel to the most important part of the subject. This can be very frustrating; we've found our faces in the mud on more than one occasion. But the results are worth the effort.

Center your subject to highlight the key element you wish to capture. Because your subject is so small, an angle of only a few inches can result in your subject's main feature being out of focus.

To get as close to your subject as possible, extend your lens out to its closest focal length. Then move your camera back and forth until you find the optimum distance from the subject. Don't adjust your lens—adjust your distance. You can fine-tune the focus with

Shooting down at this tomato would have made the stem look out of proportion to the fruit.

your lens after you settle on your composition. This will save you valuable time and frustration, especially when you're working with objects that move.

LIGHTING

Our favorite time to explore and photograph small subjects is a day with flat, even lighting. Because this is often the wrong time for shooting dramatic landscapes, a cloudy day can offer a wealth of photographic material you might not have thought to shoot otherwise. Cloudy or wet weather allows you to take advantage of this even lighting and make your day in the field fun and productive.

Bright, sunny days can create harsh lighting and prevent your subject from taking center stage. Shadows or hot spots in the background confuse the eye and spoil the composition. That's why cloudy, overcast days are perfect for shooting delicate subjects.

But what if you just found the perfect tree frog and the sun is shining brightly? Or a spectacular mushroom, hiding behind a fallen log? There are a number of tricks that can help you achieve a great photo, even in poor lighting conditions.

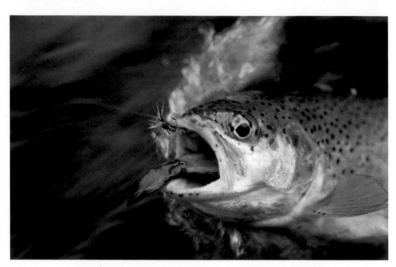

Soft, even lighting provided the perfect setting for a quick shot before we released this West Slope cutthroat.

Natural Light

Low-light conditions are common on deep forest floors or under branches where some of our favorite subjects hide. You can harness the available light and direct it at your subject with the use of a reflector. This is often enough to provide the boost of light you need to bring the subject to life in your camera lens.

A simple, inexpensive reflector can be made from a square of cardboard and a little aluminum foil or silver Mylar paper. Just cover an 8-by-10-inch cardboard rectangle with the

The bright haze of an Alaskan day gave us just enough even lighting to highlight this sockeye salmon's beautiful spawning colors. A small cardboard reflector added a little boost.

reflective material, using a little glue to keep it from slipping. Shiny, smooth foil will give off a lot of reflection, creating a spotlight effect, but crumpling the foil slightly and then resmoothing it will provide a softer, more subdued reflection. Position the reflector a short distance from your subject and experiment with the effect it creates by changing the angle at which it's placed. You can also use the reflector to highlight a background in deep shadow.

Make simple lighting aids yourself with ordinary household materials: crumpled aluminum foil makes a great reflector; cheesecloth or screen mesh can make a portable diffuser.

On the other hand, diffusers can help soften the effects of direct sunlight. Small, pocket-sized diffusers made specifically for fieldwork can be purchased at photo shops that cater to nature photographers. But you can also make your own diffuser by stretching some light mesh or cheesecloth between two frames. We make ours using a small embroidery hoop and fine window screen. The choice of material will dictate the amount of diffusion, so experiment with different materials.

Always carry a small piece of dull cardboard with you when going out to shoot small subjects. We find a standard gray card works perfectly for blocking sun that's shining directly on

Later, direct sun became a bit too strong. A portable diffusing screen softened the light hitting the image.

the subject. It also comes in handy when you want to throw the background totally into shadow, which eliminates the mottled light that sometimes causes a small subject to get lost. To shade larger areas, we have also used jackets, blankets, or even another person to cast a larger shadow than our card can make.

A combination of reflecting, diffusing, and blocking gives you the greatest degree of control over your lighting situation. Block harsh light with your gray card, then use your reflector to bounce a little soft light back onto the subject. Such techniques cover most of the situations you'll find in the field.

Artificial Light

There are special situations that require a little extra patience and additional equipment. Very low light may call for the assistance of added lighting. Likewise, constantly moving creatures such as small insects or frogs don't allow you the luxury of using low shut-

We used just a bit of flash to bring out the color of these lupines. Too little and the background would have gone black; too much would have burned out the color. We set our flash exposure 1 stop under the recommended setting to keep it from overexposing the flowers.

ter speeds or elaborate reflecting techniques. This is when flash photography is your best option.

Shooting miniature subjects with artificial light calls for a very small flash output, with a manufacturer's guide number of 30 or 40 at ISO 25; this guide number appears on the back of the flash. You should be able to choose between mounting it on the camera's flash mount (called a "hot shoe") or hand-holding it with the help of a flash cable.

Automatic flashes are fine, but they should also have a setting for manual use. Holding a large flash at a distance will create a harsh light source similar to extremely bright sunlight. Conversely, holding a small flash quite close to the subject will create nice even lighting.

In some cases the flash angle provided by the camera's hot shoe will be just right, but there are a number of conditions that call for light from other angles. Taking your flash off the hot shoe and attaching a flash cord will give you greater freedom to experiment with various angles. The strength of your flash exposure is also a matter of experimentation; automatic metering doesn't always give the best result, and you may want to bracket a stop up or down.

The best way to understand the effects of flash strengths and angles is to experiment. With the aid of a pencil and a photographer's journal, shoot your subject using a variety of angles or exposure settings. Bracket the same composition in a number of ways, and jot down the methods used. Sit down with your processed film and review the methods and the results. This is the best way that we know of to get a good sense of the various elements that affect the quality of photographs. Initially, you may feel that you're wasting film, but soon you'll find that the quality of your images has improved rapidly.

Learning to take good wildlife photos is one of the most rewarding aspects of outdoor photography, but it requires skill, patience, and a good degree of luck. At the end of the day, though, we think you'll find that the rewards are not just in the pictures you take, but in the incredible sense of wonder you get from sharing a wild animal's world for just a little while.

EQUIPMENT

Pursuing wild animals in their natural habitat is rarely performed under ideal conditions. We find our best opportunities in the early morning or late in the day, when lighting conditions are difficult. The subjects are shy and skittish and often require a lot of distance between themselves and humans. Most move very quickly. And it's often necessary to travel into remote places to pursue them.

Fortunately, the photographer who is interested in specializing in these elusive subjects has a wide array of equipment options to help. An outfit for wildlife photography, using a 35mm single-lens-reflex camera, can get expensive. Before you get started, make sure that you'll do enough of this type of photography to warrant the expenditure.

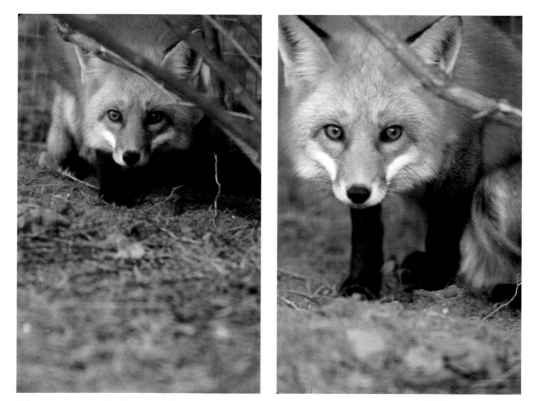

We got to shoot this fox while he was recuperating from an injury at a wildlife shelter. The image on the left was taken with a 50mm lens, on the right with a 105mm, a length we've found to be an excellent midrange lens for both indoor and outdoor photography.

ter speeds or elaborate reflecting techniques. This is when flash photography is your best option.

Shooting miniature subjects with artificial light calls for a very small flash output, with a manufacturer's guide number of 30 or 40 at ISO 25; this guide number appears on the back of the flash. You should be able to choose between mounting it on the camera's flash mount (called a "hot shoe") or hand-holding it with the help of a flash cable.

Automatic flashes are fine, but they should also have a setting for manual use. Holding a large flash at a distance will create a harsh light source similar to extremely bright sunlight. Conversely, holding a small flash quite close to the subject will create nice even lighting.

In some cases the flash angle provided by the camera's hot shoe will be just right, but there are a number of conditions that call for light from other angles. Taking your flash off the hot shoe and attaching a flash cord will give you greater freedom to experiment with various angles. The strength of your flash exposure is also a matter of experimentation; automatic metering doesn't always give the best result, and you may want to bracket a stop up or down.

The best way to understand the effects of flash strengths and angles is to experiment. With the aid of a pencil and a photographer's journal, shoot your subject using a variety of angles or exposure settings. Bracket the same composition in a number of ways, and jot down the methods used. Sit down with your processed film and review the methods and the results. This is the best way that we know of to get a good sense of the various elements that affect the quality of photographs. Initially, you may feel that you're wasting film, but soon you'll find that the quality of your images has improved rapidly.

CHAPTER 6

Shooting Wildlife

Everybody we know who has gotten hooked on photographing wildlife started out the same way: they simply found wild animals fascinating, wanted to know more about them, and most importantly wanted to experience them in their natural environment. But if ever there was a hobby that requires patience, this is it. Diehard wildlife photographers will sit for hours in cold, lonely blinds, enduring bug bites and miserable weather conditions for the chance to photograph a deer coming out to graze or a moose feeding along the edge of a lake.

Even when you have a subject that seems to be cooperative, there are many other issues. Is he doing something interesting? Is he in the right light? Can you capture him going that fast? What about the background? All inexperienced wildlife enthusiasts can point to boxes of film that were wasted because, even though they caught the animal, the composition, lighting, or pose just wasn't worthwhile.

Learning to take good wildlife photos is one of the most rewarding aspects of outdoor photography, but it requires skill, patience, and a good degree of luck. At the end of the day, though, we think you'll find that the rewards are not just in the pictures you take, but in the incredible sense of wonder you get from sharing a wild animal's world for just a little while.

EQUIPMENT

Pursuing wild animals in their natural habitat is rarely performed under ideal conditions. We find our best opportunities in the early morning or late in the day, when lighting conditions are difficult. The subjects are shy and skittish and often require a lot of distance between themselves and humans. Most move very quickly. And it's often necessary to travel into remote places to pursue them.

Fortunately, the photographer who is interested in specializing in these elusive subjects has a wide array of equipment options to help. An outfit for wildlife photography, using a 35mm single-lens-reflex camera, can get expensive. Before you get started, make sure that you'll do enough of this type of photography to warrant the expenditure.

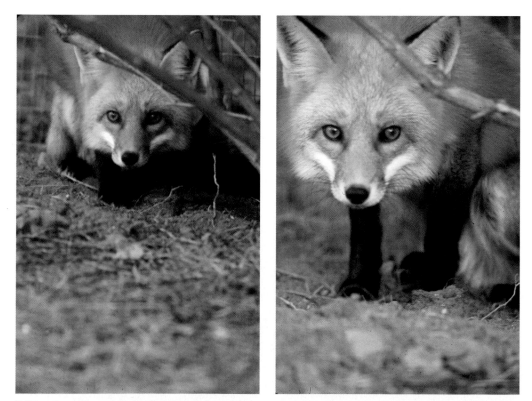

We got to shoot this fox while he was recuperating from an injury at a wildlife shelter. The image on the left was taken with a 50mm lens, on the right with a 105mm, a length we've found to be an excellent midrange lens for both indoor and outdoor photography.

The choice of lenses on the market is truly impressive, and this makes it difficult to know where to start. Our first suggestion is to begin with your camera manufacturer—see what lenses it offers in its line. You'll have a good idea what quality to expect, and the telephoto you choose may be more compatible with the other lenses in your outfit. Lenses from the same manufacturer often take the same filters, resulting in a considerable savings. You may also find that the similarities in terms of focus and metering make them easier to use.

A lens with a long focal length is an absolute must for pursuing wildlife, but you may immediately find yourself with a case of sticker shock. Long lenses can be expensive, so it's important to know what features are most important.

Because of the distances involved, a good choice for starting your outfit is a **300mm lens,** the smallest of the long-focal-length lenses, which range from 300mm to 1000mm or more. We recommend buying the highest-quality lens you can; it's disappointing to go through all the effort of stalking and capturing your subjects only to find that your images aren't sharp because you have a poor lens.

Many wildlife photographers consider 300mm too short and prefer to work with a 400mm lens. There are some good zooms on the market also, but keep in mind that high-quality

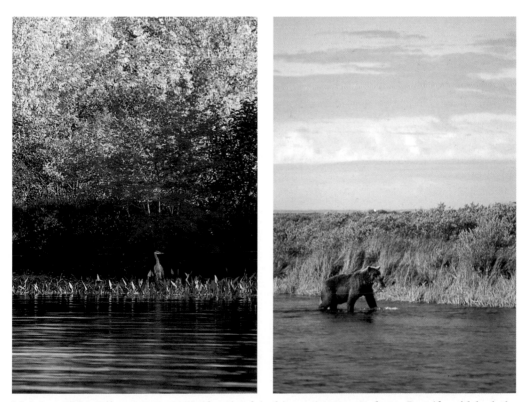

Using a 200mm lens gave us good animal-in-his-environment shots. But if we'd had the 400mm lens along, we'd have gotten more dramatic close-ups.

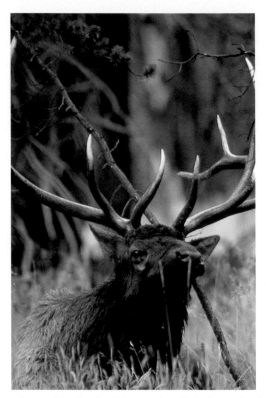

Perfect! With a 500mm lens, this Rocky Mountain elk is brought in so close that we can really appreciate his imposing frame. (Photo by Bill Silliker Jr.)

zooms are often *very* expensive. They also tend to be much heavier than prime lenses, which makes them harder to hand-hold and lug around in the field. Hand-holding any lens over 300mm isn't practical anyway, because your inability to stabilize a lens of this size will probably produce less-than-sharp pictures.

A good basic field outfit for wildlife photography includes a 35mm camera with 50mm lens, tripod, cable release, 300mm lens, clear matte focusing screen, and motor drive.

There are products that help anchor these long lenses while also assisting in tracking your subject. A **tripod** is useful, of course, for mounting your camera when you won't be moving around a lot. Invest in one that's as heavy and sturdy as you can afford to carry. It's a good idea to paint the legs and upper post in a flat black, green, or brown color to camouflage the device and prevent its shiny surface from capturing the attention of your subjects. You can also use camouflage tape—the same kind that bow hunters use. We also wrap hard-cell foam insulating material on our tripod legs; it's flat gray, and provides a little cushioning to protect our shoulders when we haul the supports around.

A **monopod** is a good choice if you're going to be working in good lighting conditions. It's a simple one-legged stand that helps stabilize your camera, but makes it a little easier to stalk. We only use a monopod when we're shooting fast shutter speeds, usually ⅟₁₂₅ second or more, because absolute stability is not guaranteed the way it is with a tripod.

For photographing birds in flight or stalking moving animals, the **shoulder stock** is very helpful. This device ranges from a lightweight aluminum support that balances on your chest to a heavier wooden gun-stock style. Your stock should be comfortable, provide good stability, and allow you to move quickly. After trying a number of styles, we still haven't found the perfect stock. This seems to be a common complaint—many photographers buy stocks and then adapt them to their particular preferences.

A **motor drive** seems to be an obvious choice for photographing moving wildlife. It's true that these devices are convenient: they're faster and less distracting than having to thumb-crank after every shot, and you don't run the risk of missing a shot because you forgot to advance the film. We would hate to be without ours. But don't expect to use it to fire in rapid sequence, assuming that you'll be able to capture the full movement of the animal. Even at full speed, you'll still only catch a fraction of the animal's motion. And with moving animals, it's almost impossible to keep a sharp focus that long anyway. You can waste a lot of film shooting this way. We find that we rarely shoot more than two or three exposures at one time.

Some photographers feel that the motor drive's noise can scare the animals. While this may be true to some extent, it hasn't been our experience. In some cases, though, such as when

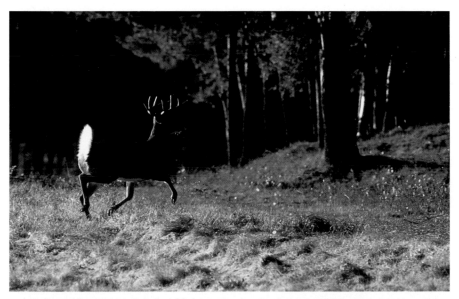

A camera mounted on a special shoulder stock was used to pan with this moving white-tailed deer. (Photo by Bill Silliker Jr.)

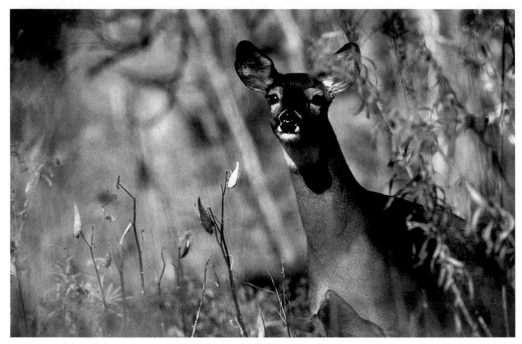

We constantly adjust our exposure so that we're ready when the animal steps onto the stage. One of a series of motor-drive shots caught this white-tailed deer as she paused to check out the situation. Bill pre-exposed in anticipation of this moment. He had less than 3 seconds to capture the image before the deer leaped into the brush. (Photo by Bill Silliker Jr.)

we're photographing songbirds up close, even the snap of the mirror is too much noise. While shooting birds nesting near our home, we have actually tried insulating the camera with foam and rubber bands to muffle the sound. But the best thing to do when your camera distracts the subject is to take a break and give your subject a chance to settle before beginning again.

If your camera gives you the choice of interchangeable focusing screens, you may want to invest in a **clear matte focusing screen** for shooting wildlife. Most camera outfits come with a split-image focusing screen. These may be fine for general photography, but we don't find them nearly as easy to use on photographs that require small aperture settings or long lenses.

ANIMAL NATURE

The most important factor in getting good photos of wild animals is knowing as much as possible about them. Wild animals inhabit a world that has little to do with ours, and they can be dangerous, particularly if you don't know what to expect.

Advance study can help you make sense of the animal's habitat. Local field guides can let you know what species can be found in certain regions and give you an idea of your subject's

favorite territories. Find out the species' nocturnal feeding habits. Learn what individuals like to eat and where. Do they move in groups or are they solitary? How do they react in various types of weather? Take careful note of their mating seasons as well as when females will be giving birth, because emotions often run high during these times.

One of the real pleasures of photographing animals is simply observing them in their natural habitat. You'll learn more from

Understanding your subjects' habits will help you locate them and anticipate their movements.

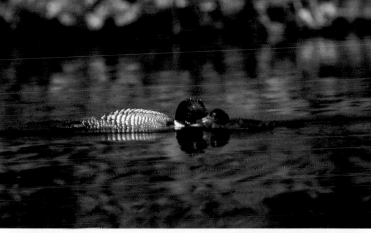

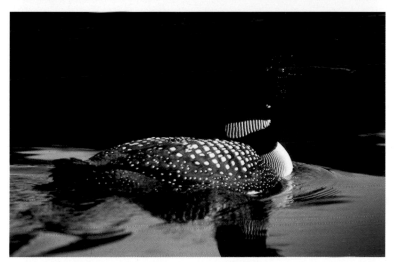

Wildlife photographer Bill Silliker makes a point of learning all about loon nature and habits from local wildlife specialists, which helps him find and photograph these shy birds without disturbing them. He's very careful not to invade their nesting sites, or to cause them to change their normal behavior patterns. He sets up in a camouflaged blind and uses 500mm and 600mm lenses to keep his distance. (Photo by Bill Silliker Jr.)

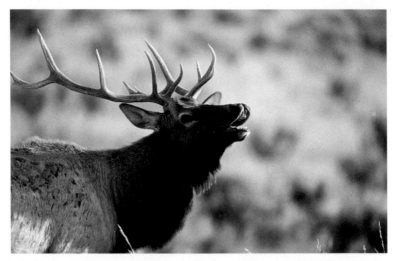

A bugling bull elk during mating season can be dangerous and unpredictable. Position your-self close to an area that can give you some protection if he gets aggressive.

one animal himself than you will from any number of books. Watch his actions and try to fig-ure out what he's doing and why. Animals rarely act randomly; almost everything they do has a purpose. A male elk pawing the ground and bugling during mating season is acting out a ritual for attracting the attention of a local female. Chances are good that he'll return to the spot often; tomorrow you can be waiting for him.

Don't let the docile nature of a grazing moose fool you into complacency. While most ani-mals are happy to ignore you or even avoid your presence, few will stand for a rapid ap-proach and none will willingly allow you near their offspring. Watch for signs of displeasure on the animal's part: a twitch of his tail, stamping a foot, or pinning his ears back are all signs that he's not happy with your presence.

Don't get too close to your subject, especially not during mating or birthing season. Approach carefully and at an angle, and avoid making direct eye contact.

Not long ago we had the rare pleasure of running into triplet black bear cubs. They were adorable and we couldn't wait to get them on film. Though Mom was not in sight, we soon heard her complaints from the brush and realized we were between her and the cubs. We hightailed it out of there—singing songs, walking slowly backward, and doing everything we could to show her how uninterested we were in her and the cubs. She followed us until she was satisfied that we were leaving, then turned back to her family. Unfortunately, all we have from that encounter are our memories!

Birds make fascinating subjects for the wildlife photographer. Because they can be found almost anywhere, they may not require

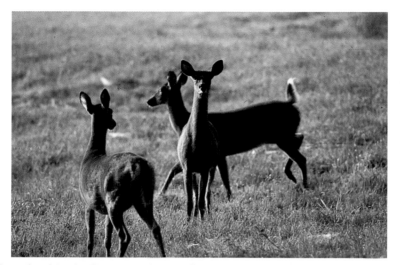

A white flag of tail is the first sign that the herd is ready to bolt. There's always one deer in the herd that's on lookout. Even the click of your shutter can cause these animals to become anxious, so we often use our mirror-lockup button to eliminate as much camera noise as possible. (Photo by Bill Silliker Jr.)

the strenuous effort that's needed when you shoot large mammals. But they do require patience.

For people who feed birds, there are lots of opportunities for pictures. It's unlikely you'll get great shots at the feeder, but there are a couple of tricks that can help put the birds into a more natural setting. We mount branches near the feeders so birds can hop off the perches and pose for us at a spot where we can control backgrounds and the birds are used to our presence. We sometimes use a flash for close-ups at the feeder. If the background isn't too close, the light falls off quickly, illuminating only the subject. Try a fast shutter speed and a relatively small f-stop to get a nice, even background: $\frac{1}{250}$ second at f16 should produce good results.

> *If you like to photograph birds, try mounting branches near the feeders so birds can hop off the perches and pose for you.*

Birds with youngsters also make great subjects, because you'll be able to easily predict their daily habits. You may even be able to install a small blind in your backyard for recording their routines: set up a good distance away, then move a little closer each day as they get comfortable with your presence. But make certain to stay away from the nest during and right after egg laying—if you frighten a bird then, it may abandon the nest.

The bottom line when photographing animals is *respect*. If they're moving away from you or doing other things that make it clear that they feel threatened, it's time to back off. A 300mm lens should provide enough distance to get good shots while maintaining the ani-

mal's privacy. As a wildlife photographer, you can help guard the delicate balance between our world and theirs.

STALKING AND CONCEALMENT

Many of the wildlife photographers we know who specialize in large mammals used to be hunters. They have traded their guns for cameras, but many of the skills they learned in years of stalking prey serve them in good stead. Camouflaging your gear will help you to keep your profile low. Wear dull clothes and try to dull your shiniest gear. But don't fool yourself into thinking that this will prevent you from being noticed by your subject. Chances are very good he picked up your scent long before you knew he was there.

Staying downwind from your subject can help alleviate this problem. We know some photographers who even keep a piece of yarn on their tripods to help them track wind direction.

Moving slowly when you're near your subject is very important. Practice being aware of every move you make. In some cases it's not enough to walk slowly. Watch your hands: they could be moving very quickly to adjust focus and exposure settings. Set a pace with which the animal can be comfortable.

There are ways to get a little closer to an animal in the wild that can be nonthreatening enough to give you a few moments to shoot. Approach him from an angle and don't pay any

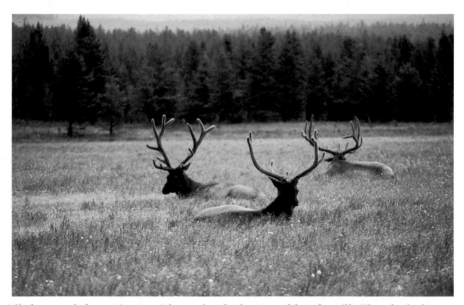

We sidled toward these giants with our heads down and hands still. They looked over at us, but evidently we were too insignificant to ruin a good nap. Yellowstone National Park.

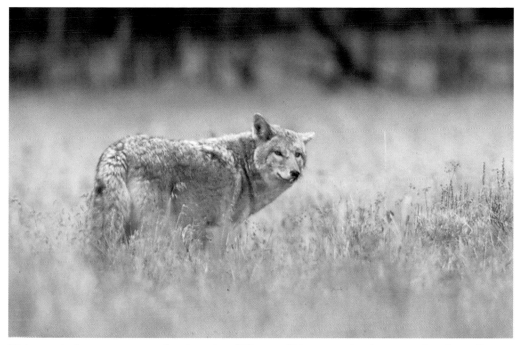

This coyote keeps an eye on the situation. When stalking an animal, stop and wait until your subject relaxes and resumes normal behavior before you take another step forward. (Photo by Bill Silliker Jr.)

attention to him. The moment he shows signs of tension, stop what you're doing and direct your attention elsewhere. Stay still and let the tension pass. Pretty soon, he'll get over his concern, and if you're lucky he'll go back to doing what he was doing. Approaching him straight on, sneaking up from behind, or staring directly at him are all acts that he may associate with aggression, so be subtle.

Blinds can be very helpful if you know where your subject is going to be, or if you expect to remain in one position for a long time. Marsh birds, for example, often live in exposed areas where you simply can't conceal yourself any other way.

Some photographers like to build blinds out of materials handy in the field. But in our opinion this requires too much reliance on luck, as well as a whole bag of tools for assembly. It can also be disruptive to the environment.

If you're going to do much of this kind of photography, it may be worthwhile to invest in a portable blind. A good blind is lightweight and easy to transport; it should also assemble quickly and allow you to shoot from a number of heights.

Don't forget that you're setting up this blind because you plan to stay awhile. Comfort is important, so make certain the blind is big enough for you to sit without crouching—a blind is rendered ineffective if you bump against the fabric and cause the whole thing to ripple.

Bring along a good seat, too; folding stools can work, but on soft ground they may sink. Try to find something with a good wide base.

GETTING THE GREAT SHOT

There are a few things to keep in mind when you're out in the field, a few tricks that can help turn ordinary shots into extraordinary ones.

Whenever possible, get your camera at the animal's level or lower, which tends to enhance the animal's appearance and create a more impressive image. Obviously, this isn't always practical, but if you have a cooperative subject, give it a try.

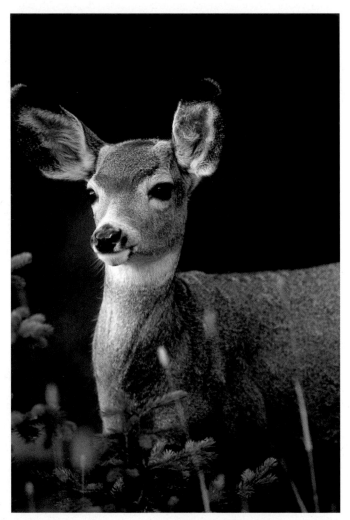

A human portrait could not be more perfect. This beautiful mule deer doe stayed still long enough to be caught in very flattering light. Spend time getting to know the area and the habits of the species you want to capture on film, as Bill did. 400mm lens, ½₂₅₀, at f3.5. (Photo by Bill Silliker Jr.)

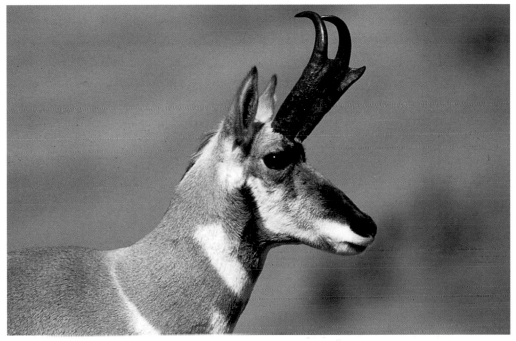

The most important feature of any wildlife shot is eyes that are in focus. Out-of-focus eyes will ruin even the best wildlife shot. (Photo by Bill Silliker Jr.)

We always say that any weather is great for photography. Even in a heavy fog we were able to capture an evocative image of this cow moose.

Pay particular attention to your subject's eyes: if they're out of focus, the entire photo will seem out of focus.

Pay particular attention to your subject's eyes when you're focusing: if the eyes are out of focus, the photo will never look right, and the entire composition will seem out of focus. Likewise, if you have a choice of compositions with or without the face and eye showing, you'll find that the shot with the eye will almost always be better.

As always, keep the background and foreground clean. It's very easy to forget your surroundings when you have an animal in your viewfinder. If you can, look around the area and preplan your shot. Patience is required. We once sat for hours waiting for a moose to cross a stream that he seemed certain to eventually cross. The rocks and grass made the perfect foreground. We had already surveyed the area and determined that no other shot was really worth getting. When he finally crossed, we were ready.

There are a lot of good wild-animal shots that capture the animal standing still or grazing. It takes patience to capture your subject at just the right moment, but it's well worth the wait. You'll be rewarded with trophies that you will definitely want to hang on your walls.

CHAPTER 7

People in the Outdoors

You probably have an idea what makes a great people picture, and your favorites are in frames around your home. But do you know *why* these are your favorites? Take a closer look. Was it the funny face she made? Or the way the sun caught his hair just right? Or did you catch the big smile as your fisherman brought in the catch of the day?

All of these photos have one thing in common: they captured a perfect moment. In some respects taking pictures of people is not all that different from wildlife photography. Sure, your subjects may not be as timid or unpredictable. But a moment's delay can create the deer-in-the-headlights look that turns a spontaneous moment into a stiff one.

The problem with off-the-cuff snapshots is that those favorite photos are rare indeed. Taking the time to learn a few tricks will make your family photo time outdoors more productive, and reward you with a larger gallery of good shots.

What makes a great people picture? The perfect moment. Pre-expose and be ready when the moment appears. How many times have we lost that magical, once-in-a-lifetime shot because we were fumbling with the camera's exposure settings?

FACES

Faces represent a special challenge for the photographer. Because a portrait is such a personal thing, you'll be subject to more opinions about your people pictures than about any of your landscapes.

Since you generally view other people at eye level, you'll get the most natural effect by shooting your subject straight on.

Consider the angle that you'll use to shoot your subject, and remember that the lens represents your camera's eye. Since you generally view other people at eye level, shooting your subject straight on will provide the most natural effect. However, there are times when shifting the camera angle slightly may help put your subject in a more complimentary position. If your subject wears glasses, make sure the frame doesn't cut through the eyes. The perfect frame will follow the angle of the eyebrows. Position your camera at a slightly higher or lower angle to remove any glare.

Getting down to children's level puts them in the proper perspective and shows them at their best.

Shooting from a little bit below provides an interesting perspective and makes children look a bit larger in relationship to their environment.

A broad forehead can be minimized by shooting down and to the side.

Lines and wrinkles are minimized with a soft-focus filter.

Children usually benefit from being shot at a lower angle. Shooting down at them from your vantage point will produce a distorted, often unflattering shot. Get down to their level, or even a little below them.

You can minimize strong features in a number of ways. A large nose can be de-emphasized by shooting the face straight on. A prominent forehead or a bald head can be minimized by shooting from a lower angle. A broad face or double chin may be slimmed or hidden with a slightly higher angle.

If your subject is sensitive about wrinkles or skin blemishes, consider using a soft-focus filter (available in varying degrees), designed specifically for portrait photography, which does a nice job of easing out deep lines or shadows.

COMPOSITION

Truly candid shots take place without the subject being aware of your presence. While this technique may occasionally produce an exquisite shot, it offers only limited opportunities. Generally, if you want to take pictures of any subjects, whether they're family members or

The fun of climbing a tree is combined with a little photo hide-and-seek to get a nice candid. We like to use tree trunks and window frames to frame children in portraits. Many times this helps get a camera-shy child involved in the photo and more relaxed.

tribal natives you meet on safari, we recommend you begin by asking permission—it may seem obvious, but getting verbal agreement is the first step in the right direction. Try to relax the subjects by telling them what you're hoping to achieve; engage them in conversation while your mind is racing with exposures, angles, and such. If they don't speak your language, use hand signals and lots of smiles.

A certain amount of posing is a necessary evil—capturing your subject on the fly is rarely practical. Saying, "Stop right there!" when you see something you want will probably result in a stiff pose and an uncomfortable smile. A relaxed, natural pose is what you're looking for, so watch for signs of tension. Hands should be gently curved, and neither wide open nor clenched. Elbows should be not bent stiffly but dropped slightly, to form a graceful curve. One foot should be ahead of the other, with the back foot taking most of the weight, which gives the body a sense of ease. If necessary, have subjects cross their knees or ankles to put them in a more relaxed position.

Watch for signs of tension in your subjects and take time to help them relax: hands should be gently curled, elbows dropped slightly to form a graceful curve. Use props to put your subjects at ease.

Props make a photo more interesting and give your subject a focus that will help ease the awkwardness of posing. Consider shooting a father leaning on his golf clubs, or a best friend on her mountain bike. Often you'll notice a glow of confidence that

We kept this model (our daughter Brooke) relaxed by having her get up and wiggle every minute or so until we had the shot we wanted. Overcast days are great for outdoor subjects, including people photographs: the soft, even lighting eliminates shadows and high-contrast highlights.

Getting our kids ready and shooting them with props just before they hit the river let us capture their true personalities with a relaxed and cooperative attitude.

Future big-league stars? Capturing the moment comes from understanding exposure and composition so you don't have to stop and think. You can quickly adjust and shoot.

accompanies the happy association your subjects have with their favorite activity. When composing a shot, always ask yourself: would this be better with a prop?

Of course, you'll get complaints from your subjects if you spend a lot of time fussing with all these issues—this isn't a portrait studio, after all, and they're outdoors to have fun. If you make your subjects wait for the perfect angle, light, and exposure, don't be surprised if you end up with stiff smiles and unnatural poses.

It's good training to start with a willing victim who will let you practice in the backyard. Take lots of shots at various exposures and study them after they're developed. Try to make your technique become second nature, so you don't have to fuss with your subjects when you're outdoors with them.

LIGHTING

In general the best time to take outdoor pictures of people is midmorning or midafternoon, preferably when there's a light cloud cover. These conditions produce lighting that's flattering to almost anyone. There's just enough direction to the shadows to produce definition, but not so much as to cause your subject to squint. These conditions are transient, though, and you'll often have to work with lighting that's less than perfect.

You'll also find that you can get great shots from lighting that's completely flat. The advantage to this type of light is that it casts your subject in a soft, flattering light and allows the

eyes to relax. Contrast is low, and colors are saturated. The draw-back is that the light has no direction, causing little definition on the face. This problem can be easily remedied: simply using a soft reflector to bounce a little light toward the face is usually enough to give you exactly the effect you want.

If you do have to shoot in bright sunlight, follow these tips. First, never shoot at high noon! This overhead lighting causes nose and eye shadows that are very uncomplimentary. Second, turn your subject away from the sun so that the face is protected from the sun's glare. Take your meter reading up close to your subject's face, then step back to take the photo.

It's generally best to compose your subject so that the scene is either completely in sunlight or completely in shade. While you might find a backlit scene pleasing, your film will have a hard time

Flat lighting casts your subjects in a soft, flattering light and allows their eyes to relax. Just use a small reflector to bounce a little highlight onto the face. Never shoot at high noon, when light causes harsh shadows that are very uncomplimentary.

Soft, directional light can be very attractive, as long as it's not too strong.

Heavy contrasts of shadow and light cause problems for any scene. Bouncing a little reflected light onto this trio would have improved the shot.

handling the extreme contrast of light and dark. There are certainly times, though, when a backlit effect can be used to advantage—highlighting hair or setting a romantic scene in silhouette can produce great shots. Just remember that these situations call for careful attention. Your meter can be confused by the variation of light in the frame, so know what you're metering for to achieve the best effect.

If your subject's face is in deep shadow (we find fishermen notorious for refusing to remove their hats, and the brim casts a deep shadow that makes a good shot very difficult), you can use a weak flash to fill in the dark spaces while leaving a bit of shadow. There are many complicated formulas for calculating the amount of flash to use, but we use this rule of thumb for fill-in flash: first meter the face for perfect exposure; then turn on your flash and adjust your meter setting down 1 stop. If the shot is important, always bracket: take one shot at the recommended exposure, the next ½ stop down, the next a full stop down. This will ensure that at least one shot will be perfectly exposed.

Four versions of the same situation. At top left, the shot is busy with jungle gym and trees behind. The top right is cute, but the horizontal direction cuts the action in half. The bottom left has potential: the low angle gives the child a position of power. But we like the bottom right: the perspective is straight on, the vertical direction gives the movement energy, and the chain reinforces the action.

Fishermen! They're so excited about their fish that they don't think about how their faces will look in the final photo. Lift their heads and push the hat brims back a little. This will improve the shot dramatically and make it much more memorable.

SPECIAL CONDITIONS

Winter

Winter is a wonderful time to capture people at play—cross-country skiers, downhill skiers, skaters, and sledders are all great subjects. But they pose special problems.

If you take a meter reading off your brilliant snowscape, the meter will indicate a lower exposure to compensate for the large expanse of brightness. To capture the whiteness of the scene, open the lens about 1 f-stop or decrease shutter speed 1 stop to compensate. To properly expose people on the snow, meter off their faces, if possible. If this is impractical, use a gray card to get a neutral reading and use that exposure. As with other types of people photos, a late-afternoon sun will give you a nicer range of shadows and light to capture your subjects.

A polarizing filter will sharpen the blue sky and remove the reflected highlights on the snow's surface. Your shot will benefit

> *To properly expose people in a snow or water setting, take a meter reading off their faces, if possible. If you can't, then meter off a gray card to find the right setting.*

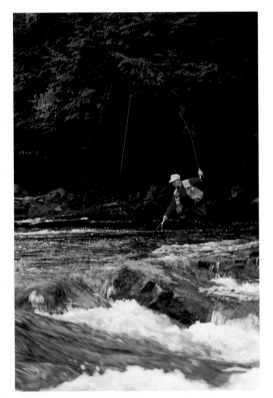

There are a number of things that make this photograph successful. Even lighting, the angler's position in the frame, and the splash of red shirt against a dark forest add up to a great shot.

from enhanced definition and color saturation. A polarizer will reduce the light reaching your film by 1 or 2 stops, so factor this in if you're not metering through the lens.

Water

Like snow, water reflects a lot of light, and through-the-lens metering of a water scene will result in an image that's underexposed. Adjust your meter setting ½ stop to 1 full stop down to compensate for this reflection. Use a polarizing lens to reduce the glare and to enhance the color saturation. And consider the angle of the light: water can sparkle, reflect, or become dull and lifeless, depending on how the sun is hitting it. If you can comfortably look at the water, you can probably photograph it. If, on the other hand, you have to squint to look at the surface, even a polarizer may not be able to help you achieve a good shot. Change your angle to achieve a better balance of light and shadow.

PEOPLE IN ACTION

Since so much of our personalities are wrapped up in what we do for fun, it's not surprising that some of the best people photos are taken when they're on the move and deeply engaged, and their self-consciousness has evaporated. But it also means that as the photographer, you must be on your toes: good action photography requires a quick command of the requirements of exposure, composition, and environment. Planning ahead as many factors as possible will allow you to concentrate on the action when it occurs.

Start with the setting. If possible, scope out the place where the action will occur, visit it ahead of time to locate vantage points, and take a look at the exposure requirements. Preset your exposure, determine how much of the scene you want to take in, and choose your lens.

Action photos call for a fast shutter. Some cameras have shutter speeds as high as ½₀₀₀ second, but it's the rare event that calls for such a fast shutter speed. The table below gives you an idea of the types of shutter speeds needed to freeze action.

Shutter speeds that are fast enough to freeze action may not provide you with enough light to get the proper exposure. That's where faster film comes in: a shot that requires an f1.8 setting with ISO 200 film will only need an f4 setting if you choose ISO 400 film. ISO speeds now reach as high as 3200, so if you're going to do a lot of action photography, experiment. Remember that

Minimum shutter speed required to stop action when subject is in full frame (if your subject is farther away, a slower speed can ususally be used)	
Runner	⅟₂₅₀
Fisherman casting	⅟₂₅₀
In-line skater	⅟₅₀₀
Cyclist	⅟₅₀₀
Tennis server	⅟₁₀₀₀

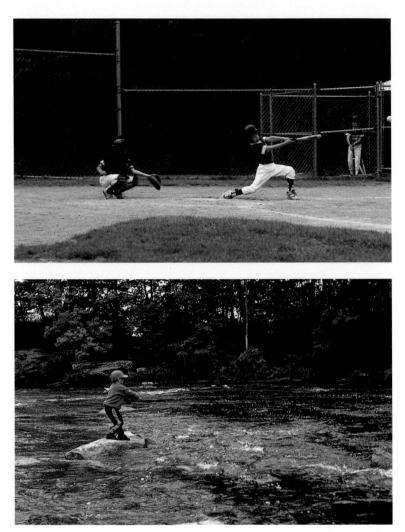

Plan ahead to get the great shot. Prefocus, establish the proper exposure, and wait! In both photos the shutter speed was critical: we shot at ½₂₅₀ to stop the motion.

higher-ISO films will be a little grainier than lower ones, although with the quality of films available, this is not usually a deterrent unless you plan oversized enlargements.

　　If you're on location with only one type of film, there's another option: **pushing your film,** or setting the film-speed dial 1 or 2 stops up from its assigned ISO rating. For example, if you're using ISO 400 film, turn the dial to 800 to increase your shutter speed 1 full stop. The whole roll must be shot at this revised ISO to get proper exposure of all frames. When you send your film to the lab, ask the processor to increase development for the ISO you chose. The longer development causes a little more graininess and dulls the color slightly, so use this technique only in a pinch.

*Even in the middle of the day you can shoot silhouettes. We underexposed by 2 stops to cap-
ture the form of these people in shadow against the bright sand.*

Learning to prefocus will help you be ready when the action begins. Even if you have an
auto-focus camera, the delay caused while the camera evaluates sharpness may cause a prob-
lem. You can eliminate delays by determining where the action is going to occur, then focus-
ing on that spot and releasing the shutter when the subject enters the frame. Timing is cru-
cial—pressing the shutter a fraction of a second early or late will cause blurriness. Practice
anticipating the moment.

*Sometimes you just have to grab and shoot! The better you understand your camera and the
more prepared you are, the higher your percentage of good photographs will be.*

Panning helps you capture movement, even while you're using a relatively slow shutter speed. This technique creates a blurred background that accentuates the in-focus motion in the foreground.

Panning is a technique that you can use to stop movement, even while using a relatively slow shutter speed. By following a moving subject across the frame with your camera during exposure, you can reduce the rate of movement while creating a blurred background that accentuates the sense of motion in the foreground. This technique takes practice: start by choosing a location in the desired proximity of the action. Set your shutter speed at $\frac{1}{25}$, prefocus, and stand squarely facing your chosen spot. As your subject approaches, swivel your body to pick it up in the viewfinder. Keep the subject in the center of the frame until it's almost directly in front of you, and press the shutter. Follow through smoothly after the exposure to avoid any distortion.

On the other hand, sometimes you just have to shoot. If you see something interesting that you know won't last, grab your camera and shoot fast. Forget about technical considerations for the moment. You'll be pleasantly surprised by how many of those snapshots result in interesting photos—images that you would've missed altogether if you'd paused to get everything just right.

CHAPTER 8

Encountering the Unusual

The earth offers a wide range of environmental conditions to explore and photograph, and we try to exploit the beauty of nature's many moods every day. We count on dramatic cloud conditions to enhance our images, wispy fog to soften damp days, and spectacular sunsets to finish out a successful shoot. But what about capturing the really rare moments, the once-in-a-blue-moon events?

WILD SKIES

There's hardly anything more miraculous to the outdoor photographer than a sky full of light and shadow, color and darkness. Whether it's a vivid sunset, a brooding cloud bank, or even the perfect blue backdrop, the sight of the sky excites our imaginations and gives us a palette of colors.

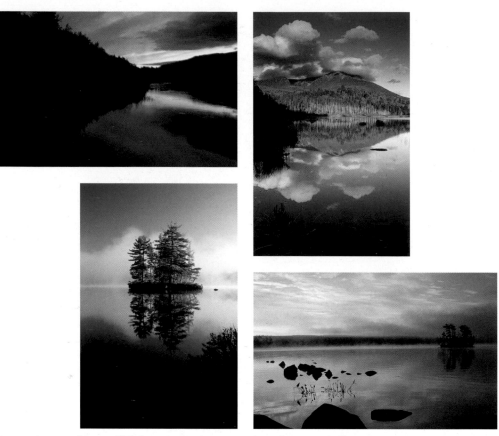

Deep crimson skies, still lakes, and misty morning shores are all great reasons to get up at 5 A.M. to be at your chosen destination. All photos were taken using a tripod and shutter speeds of 1 or 2 seconds.

But capturing the sky the way your eye sees it can be more difficult than you imagine. There's a lot of light to contend with, and without a few tricks you might have to sacrifice the perfect sky to get the landscape properly exposed.

Virga, Rainbows, and Clouds

Use a polarizing filter to intensify the colors of a rainbow. Rotate the filter until you see the rainbow at its best.

Virga are streaks of precipitation, such as water or ice particles, that fall from clouds but evaporate before reaching the ground; from a distance they can sometimes be mistaken for funnel clouds. Rainbows are formed in a similar manner, when the sun's light is reflected on raindrops or mist. From the photographer's viewpoint, these are similar events. They only appear if conditions are right, and then are often fleeting. Both virga and rainbows can be captured on film with the help of a polarizing filter to intensify the colors; rotate until you capture the image to your satisfaction. But

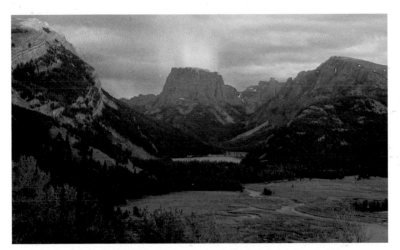

We hiked 2 miles into the Wind River Range to photograph Square Top Mountain, then a storm moved in and it seemed we wouldn't get a view of the peak. But a few minutes before the sun went down, an opening in the cloud bank gave us this once-in-a-lifetime image of the virga phenomenon. Moments later, it vanished.

Rainbows are transient, too. Use your polarizer to maximize the effect. A 45-degree angle from the sun will give you the brightest rainbow. Rotate the bezel on your polarizing filter until it maximizes the effect. (The top image was taken by Val Atkinson.)

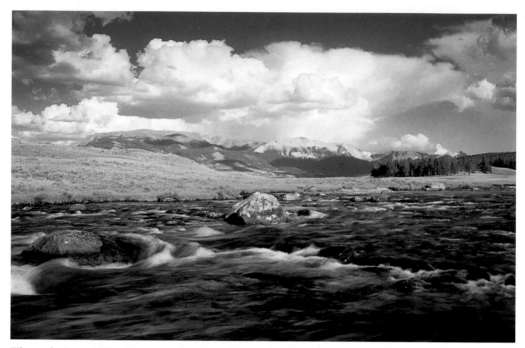

The polarizing filter darkens the blue sky and emphasizes cloud detail. Contrast between clouds and blue sky is increased, creating a more dramatic image.

if your polarizer is turned the wrong way, the rainbow or virga will disappear entirely from your viewfinder.

Clouds also benefit from the use of a polarizing filter, which will darken the blue of the sky, providing the perfect backdrop for the bright clouds. If you're trying to balance a landscape scene with maximum cloud impact, try a **graduated neutral-density filter.** This will darken the upper part of your image without affecting the lower portion that features the landscape.

Sunrises and Sunsets

To determine your best exposure setting for capturing a sunrise or sunset, don't take your meter reading with the sun in the viewfinder, but on either side of the sun.

Sunrises and sunsets are those magical moments that turn ordinary people into photographers—the colors challenge you to grab a camera and start shooting. To make the most of this opportunity, meter carefully: don't take your reading with the sun in the viewfinder, but on either side of the sun. Try to compose with an interesting foreground. When we're in a new place, one of the first things we do is note where east and west are, and where a likely sun shot could occur—that is, we compose *before* we ever see the sunrise or sunset, so when color starts to show in the sky we know

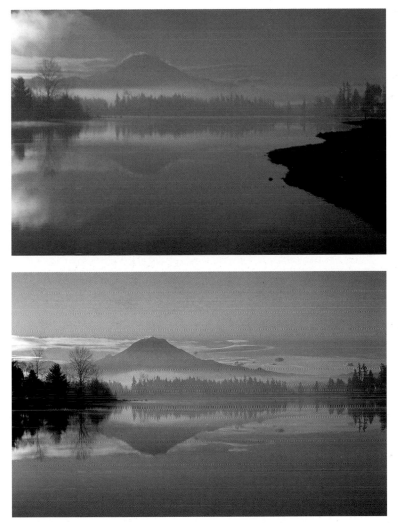

*The first rays of morning light wash Mt. Rainier in brilliant orange. Scouting for locations
the day before, we had come across this spot. When the sun rose we had only 10 minutes of
good light: then the color changed to a muted silver. Because we prepared in advance, though,
we were able to capture these images in the brief moments available.*

exactly where to head. A warming filter (81B) can intensify the redness of the sky, but we like
to find those moments that don't require any help to be spectacular.

Lightning

The drama of a lightning strike makes a spectacular photo opportunity. Of course, these
aren't easy images to capture, and timing and safety are everything. If you're going to set out
to capture your next local storm, scope out the area during nice weather: you'll need a place

Trying to capture lightning can be as difficult as trying to catch the tail of Haley's Comet—patience and luck also play important roles. Shutter speed set on "B" for bulb, left open for 3 minutes waiting for the lightning to strike again; aperture set at f2.8. (Photo by Val Atkinson.)

to shelter—check the windows in your house to see if you can shoot from your home. Avoid places that tend to flood, and don't stand under trees for shelter.

We usually try this type of photography at night, when it's possible to capture lightning bolts that are 4 to 5 miles away. Look for a location that has a wide-open vista of the sky, and make certain that there aren't any bright lights in the area from houses, headlights, or distant streetlights, which will ruin the image. STOP SHOOTING IF THE LIGHTNING STORM IS NEARBY.

> *Try catching lightning at night: it's easier and safer, because you can work with lightning bolts that are 4 to 5 miles away.*

To capture the images on film: select film with a low ISO, which will allow you to keep the shutter open for a long period without worrying about the effects of stray light. Mount your camera on a tripod and attach your cable release. Set your camera on the "B" shutter-speed setting, and your aperture at about f11. Then simply open the shutter and wait. If the lightning bolts are in the distance, try to get more than one strike recorded before you advance your film and start again. If it's a very bright, nearby flash, advance film after each strike.

FOLLOWING THE HEAVENS

Any 35mm camera with a time-exposure setting can be used to take pictures of the moon and stars. You can use a normal lens to capture star trails or place the moon in a landscape setting.

If you want to record images of stellar objects, it's also possible to attach your camera body to a telescope, whose manufacturers offer adapters for attaching to cameras.

Star Trails

One of the most interesting and easily shootable nighttime images is a recording of star trails. This makes a striking image, especially if you can include the silhouette of a mountain or other interesting skyline. Be careful, though, when choosing your location: avoid stray light from buildings or cars that might fog your film. The best time to photograph star trails is on a moonless night or early in the morning; the best place is a location away from the city. Our favorite time to photograph star trails is when we're on backpacking trips, far away from any stray light.

Use a 35mm camera that has a time-exposure setting with a normal or wide-angle lens. Medium- to high-speed film (ISO 125 to 400) will give you the best results. Your aperture setting will determine the width of the trails. Wide open will produce thicker trails, but you may not like the softness of their edges. Stopping down your lens will require a longer exposure but produce thinner, sharper streaks. The best thing to do is experiment to determine what kind of image you like best.

You can record circular star trails by mounting your camera on a tripod and pointing it toward the North Star. Open your shutter from 15 minutes to 4 hours, depending on the length of star trail you desire.

Because of the earth's rotation, stars appear to revolve around a point directly above the earth's axis, marked by the North Star. To record circular star trails, mount your camera to a tripod and point it toward the axis point. Open your shutter from 15 minutes to 4 hours; the length of time that you record will determine the length of the resulting star trail.

If you're looking for a precise trail length, use the following calculation for determining the length of the star trail versus the time needed for a given lens.

$$\text{Length of trail on film} = \frac{\text{Focal length of lens (inches)} \times \text{time (minutes)}}{229}$$

For example, if you want to record a ¹⁄₁₀-inch star trail on film, you'll need to shoot with a 5-inch-long lens for 4.5 minutes.

The Moon

The biggest challenge in moon photography is getting the moon to appear on film as large as it did in real life. Very often, moonlit landscapes that seemed perfect on location are disap-

pointing because, on film, the moon is too small. Instead, calculate the size the moon will appear on your film using this formula.

$$\frac{\text{Focal length (mm)}}{100} = \text{approximate size of moon on film in millimeters}$$

A 100mm lens, for instance, will produce an image of the moon on film that is only 1 millimeter, or about ⅟₂₅ inch. By using a 400mm lens, you can increase the moon size to almost ⅙ inch.

That's why serious night photographers sometimes resort to **multiple exposures,** for a couple of reasons. First, capturing the landscape image is going to require a relatively long exposure time, and if you shoot the moon at the same time, it will take on an oblong shape. Second, the moon's size will be very small in relationship to the landscape.

Try the double-exposure technique next time you're shooting nighttime images: shoot a landscape that appeals to you, but leave an area at the top of the film where nothing is recorded (it helps to be working with a black sky). Take a second exposure on the same frame using a telephoto lens to enhance the size of the moon.

If you keep your shutter open too long, you'll begin to capture the moon's movement, and an elongated moon will replace the round one. 200mm lens for 1 minute at f3.5.

Even the weak light of the moon can be used to illuminate your shot. Here, a long exposure begins to give some definition to the surrounding landscape: 2 seconds at f2.8, 200mm lens.

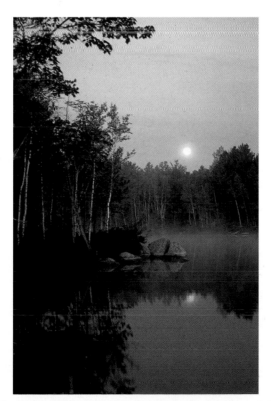

This first morning light has a magenta cast that paints the world and the setting moon a soft pink: 2 seconds at f5.6, 28mm lens.

You can also shoot beautiful landscape images using the light from the moon as your light source, but don't include the moon because it will blur the image. Use the chart below to determine your exposure setting; these times will produce images with heavy shadow areas. To get the kind of shadow detail that's characteristic of a daylight shot, multiply the exposure times by 4. Note that the times in this table are starting points only; the angle of the moon will also affect exposure. Be sure to bracket additional exposures to ensure a good image.

Lunar Phase	ISO	Exposure Time (seconds)	Aperture
Crescent moon	64	1/15	f5.6
Half moon	64	1/60	f8
Full moon	64	1/250	f8

The Sun and Solar Eclipses

WARNING: Shooting images of the sun is dangerous, both to the photographer and to the equipment. We recommend that you avoid shooting *any* image that includes the sun. Never look at the sun directly through any kind of optical instrument with the naked eye: the ultraviolet and infrared rays can cause permanent eye damage before you even realize what's happening. The sun's rays can burn through your camera's cloth focal-plane shutter and the film's emulsion.

There are methods for recording solar eclipses, and if you're very interested in this sort of photography, your best information will come from books on astronomy. Filters are available for protecting eyes and equipment, but this type of photography has very specific requirements, so don't attempt it unless you're fully prepared.

AERIAL PHOTOGRAPHY

Photographing rugged landscapes from the air can provide an interesting perspective that you can't achieve any other way. One of our favorite photographs is a shot of the point we live on here in Maine. Though we can't actually see the water from our house, this image reminds us of our place in the world and our proximity to the wide, wild ocean.

A commercial flight is not the place to get aerial photographs. While we admit to occasionally snapping an image out the window of an airliner, the reality is that there are simply too many environmental factors in the way to achieve good images.

Use a haze or polarizing filter for aerial photography; it'll reduce the haze caused by UV rays in the atmosphere.

The best way to get great aerial shots is to plan an excursion specifically for them: hire a pilot with a small plane and explain your goals, ask for scheduling flexibility to accommodate weather and lighting conditions, and plan on passing the area you wish to shoot several times.

A floatplane or helicopter is the perfect way to see the world from the sky. Consider hiring a pilot to help you photograph your community or a special area from a completely different vantage point.

The rough landscape of a glacier and the magical curve of land and water were all captured from airplanes. A polarizing filter cut through the haze and toned down the reflected light.

You'll need a filter to compensate for the haze caused by UV rays. You can use a haze filter, but with color film, a polarizer will probably handle the haze well enough and give you the added advantage of helping you cope with reflected glare.

The following chart offers the slowest recommended shutter speeds for aerial photographs. Again, experiment with bracketing to achieve the best results. And remember that these numbers don't take into account compensation for helicopter vibration, long lenses, or film size—all conditions that may require faster shutter speeds than those listed.

	Ground Speed (mph)						
Altitude (ft)	75	100	150	200	250	300	350
4000+	–	$\frac{1}{60}$	$\frac{1}{60}$	$\frac{1}{125}$	$\frac{1}{125}$	$\frac{1}{250}$	$\frac{1}{250}$
3000	–	$\frac{1}{60}$	$\frac{1}{125}$	$\frac{1}{125}$	$\frac{1}{250}$	$\frac{1}{250}$	$\frac{1}{500}$
2000–	$\frac{1}{125}$	$\frac{1}{125}$	$\frac{1}{250}$	$\frac{1}{250}$	$\frac{1}{500}$	$\frac{1}{500}$	
1000	–	$\frac{1}{250}$	$\frac{1}{250}$	$\frac{1}{500}$	$\frac{1}{500}$	$\frac{1}{500}$	$\frac{1}{500}$
500	$\frac{1}{250}$	$\frac{1}{500}$	$\frac{1}{500}$	$\frac{1}{500}$	$\frac{1}{500}$	$\frac{1}{1000}$	$\frac{1}{1000}$

CHAPTER 9

The Special Challenges of Fieldwork

Our cameras have taken us places we would never have dreamed of going otherwise. And we find that the more we shoot, the greater our wanderlust grows.

But there are many different conditions that make photography a challenge. If you're planning a trip to an area you've never been, make sure you understand the weather before you get there. Having the right gear and accessories for coping with conditions will help you have a productive and enjoyable photo excursion.

BASIC CAMERA PACKS

There's a wide assortment of camera bags and packs on the market, probably a bag for almost any condition you might encounter. Consider how you'll be using your equipment before you decide on the bag that's right for you.

Will you be traveling by car most of the time? Then the answer may be a hard-sided case with foam compartments that keep everything safely in place and readily accessible. Have a separate padded case that's big enough to carry a camera with lens and motor drive already mounted. That way you'll be ready to shoot when you take off on short excursions.

If you travel by air, find a bag that passes the airline's carry-on size guidelines. Always hand-carry all of your equipment, including your tripod, and ask for hand-inspection.

If you travel by air, find a bag that passes the airline's carry-on size guidelines, and *always* hand-carry all of your equipment, including your tripod. Ask that it be inspected by hand at the security checkpoint, because X-ray machines can damage film. If you normally work out of a different or smaller bag, that can be packed with the rest of your luggage.

For backcountry photography, there are some really good backpacks designed specifically for camera equipment. The Trekking series by Lowepro has almost any configuration you could want. We use the Super Trekker AW, which comfortably carries up to 50 pounds of gear and has all the features you'd look for in a conventional backpack. We also take along a padded fanny pack that holds a camera with lens, one additional lens, and film.

COPING WITH WEATHER

Cold

Today's modern camera equipment is better able to tolerate temperature extremes than cameras of the past, and modern lubricants make it unnecessary to winterize a camera. Still, there are a couple of important steps to take in extremely cold conditions.

Cold weather causes a huge drain on batteries: always start with fresh ones, and if you'll be in the field for more than a few days, bring spares.

First, make certain that your camera and lenses have had a good cleaning, and test your equipment thoroughly to avoid surprises in the field. Second, be aware that cold weather causes a huge drain on batteries. Always start with fresh ones, and if you'll be in the field for more than a few days, take along spares. A weak battery can cause inaccurate meter readings, and a dead battery can prevent you from releasing the shutter. In general alkaline batteries perform better than zinc, lithium a little better than alkaline, and silver oxide or manganese batteries better than lithium. Nickel cadmium batteries are impractical in extreme cold: they operate at only about 60 percent capacity in temperatures below 0°F, and must be recharged at temperatures of 50°F or higher to prevent damage. Motor drives are designed to use a lot of

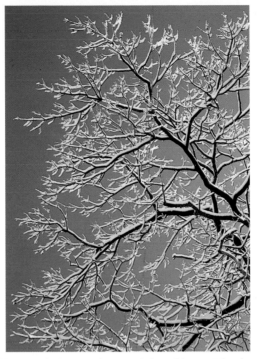

Winter photography offers a whole set of potential problems. The day of the snowstorm that covered this tree, the temperature dropped to near 0°F. Such extreme cold can take a toll on equipment. Be careful not to breathe on your equipment, because the resulting condensation can fog and freeze lenses and viewfinders.

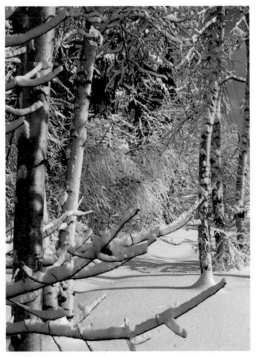

For this photo, we used our fully manual FM2 camera, which allows us to use manual rewind when we're done with a roll of film. Automatic winders can sometimes move too fast and create static-electricity lines across the film.

power, so keep reserve batteries warm in a nearby pocket if you're using your motor drive. Use the drive in slow mode to avoid static electricity, and rewind manually, if possible.

A camera body with a black finish will absorb some heat when the sun is shining, a benefit to both camera and film. Some cameras are now made of polycarbonate, which is more comfortable to use than a metal body is. If you're using a metal camera body, be careful when placing it against your face: it can cling to your skin. To avoid this, use duct tape on the parts that will come into skin contact.

Plastic and rubber parts and accessories can become stiff and problematic. A plastic carrying strap can get brittle and break, so consider using a leather strap. Cable releases with metal sleeves are more reliable than those with plastic sleeves. Likewise, a wooden tripod will be easier to use than a metal one: there's less risk that condensation will cause problems, and your skin is less likely to stick to the surface. You'll probably want to use a lens shade to reduce glare from bright snow conditions. Because these are usually rubber or plastic, treat them carefully to avoid cracking.

Gelatin filters won't work in extremely cold conditions; you'll need to use solid glass models. Keep a UV filter on your lenses at all times to reduce the amount of ultraviolet light and prevent damage from wind or blowing snow.

If you usually shoot slide film, you might want to consider using color print film for cold-weather shooting. While film's emulsions are not adversely impacted by the temperature, there's a certain amount of color shift that takes place owing to the low angle of the sun. In some arctic regions the sun never gets high enough to create true daylight conditions. Print film is easier to correct for this color shift.

The primary concern with film in cold conditions is maintaining its physical properties. In temperatures below 0°F film becomes brittle; the emulsion may crack or the film may break. Take extreme care when loading and unloading film, which is when most film is broken. Advance film slowly to avoid damage and to reduce the chance of static charges. These are more common in cold conditions and show up on developed film as marks resembling lightning streaks, beads, or dark rings. And it may be best to stop shooting 1 or 2 frames before your final exposure, to avoid ripping the film as it reaches the end of the roll.

Protecting your hands is one of the most important aspects of dressing for winter photography. Of course, anything that reduces your sensitivity to the camera will feel somewhat clumsy. Consider wearing silk liner gloves under bulky wool gloves, and pin the bulky gloves to your jacket sleeve so you can slip into and out of them without dropping them. We also like gloves with pull-back tips when conditions aren't too cold. Remember that it's sometimes hard to know just how cold you're getting until it's too late. Skin reacts badly to cold metal, too, so keep covered!

Wear clothing that's roomy and has large pockets. Store batteries in a pocket where your body will keep them warm. Keep your camera on a neck strap and tuck it inside your jacket to keep it warm when you're carrying it. Try a fanny pack, worn in front for easy access to accessories. If you're carrying a separate bag, make sure it's insulated and that the material has been treated for weather resistance. Throw in a couple of hand-warmer packets to maintain some heat inside the bag.

Be careful not to breathe on any part of your camera equipment, and when you're preparing to shoot, try to hold your breath. The condensation from breath that forms on your lens or viewfinder will fog and freeze. Be careful not to breathe on the film back when loading film.

The biggest problem with condensation occurs when you go indoors. Moisture in the warmer interior air will cause water to form on the camera, inside and out. So take precautions: seal your camera in a reclosable plastic bag before entering a warm room, and enclose some packets of silica gel, which can be purchased at many camera shops and drugstores. It's important for your camera to warm up slowly, so leave it in a cold area when you first come in—a cold porch or even a cold corner on the floor—and gradually bring it back to room temperature. If your equipment does get wet, immediate action is needed. A hair dryer set on low will complete the drying process. Never take the camera out while it's still wet. Small droplets will freeze inside and jam your mechanism.

Heat

Hot conditions cause a different set of problems for the photographer—and they're not limited to desert photo shoots or hot summer days. Even in normal weather, ordinary car travel often causes more heat than the average film can tolerate. Be prepared.

In general cameras, old and new, handle hot conditions pretty well. But if you're going to be in hot conditions for an extended period, be aware that lubricants will eventually thin and run. Cements used to hold lens elements together can soften, so avoid sudden jolts to your camera equipment in these conditions. Telephoto lenses can expand a little if they are struck by the hot sun, and you may have trouble focusing to infinity. And because most lenses are black, they may even get too hot to handle. The best remedy for most of these problems is simply to keep your equipment shaded. Carry an umbrella or lightweight space blanket to shield equipment. Heat also shortens battery life, so keep a supply of extras. Hot conditions can even cause batteries to break down and leak, so we store spares in the cooler with our film.

The biggest challenge you'll face in hot conditions is maintaining the quality of your film. Almost all film properties are affected by heat, which can soften the emulsion, causing images

Heat can soften film emulsion, causing images to lose definition and colors to fade. Always have a plan for keeping film cool.

to lose definition; film can also fade before you get it to the processor, causing poor color resolution. If you normally prefer professional film versions, consider switching to the amateur versions, whose difference in heat tolerance is about 20°F.

Always store film to maximize coolness. Aluminum cases are good for equipment, because they reflect the heat away. For film, we always bring along a cooler with a tight-fitting lid, lined on the bottom with reusable freezer bottles. Soft, zippered, lunch-type insulating coolers are okay for short trips—we transfer the day's film into one of these, again with a small freezer pack, for carrying in our camera bags. On location we sometimes buy inexpensive Styrofoam coolers, then leave them behind for others to use. These work in a pinch, but be careful to weigh down the lid for a tight fit, especially if it's very humid. In the backcountry you can keep film cool by burying a sealed bag in a shallow pit.

Temperatures in desertlike areas can skyrocket in bright sunshine, even in winter. The biggest problem with heat is film damage: always carry a cooler along to protect your film in the car.

Take along only the film you'll need for the day's shoot. Always warm up film gradually before opening the factory-sealed package, or you may wind up with condensation. You should take at least an hour to raise a roll of film's temperature by 30°F. When you return from the day's shoot, store exposed rolls in a sealed bag with silica-gel packets until you can get them to the processor. When we're traveling, we often process film along the way. The developed transparencies are much more stable, and we can leave the area assured that we got the shots we needed.

Humidity

Prolonged humidity of 60 percent or more, regardless of the temperature, can cause a lot of damage to cameras and film. The biggest culprit in these conditions is the variety of fungi that thrive in moist environments: mold and mildew can ruin camera bodies and make moving mechanisms sluggish. Zoom lenses are especially prone to problems, because they pull in more damp air than fixed lenses do. If you're traveling in extremely humid conditions, you may even want to consider carrying a waterproof camera or using an underwater housing.

Keep your storage cases as dry as possible. Leather bags are especially prone to attack by molds, so you may want to leave these home. Wrap regular cases in double-layered plastic

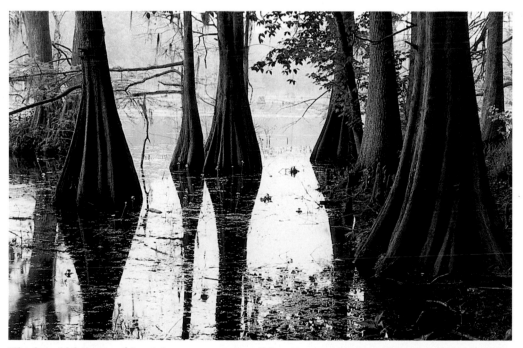

The humid bayous of Louisiana can cause mildew to grow on equipment nearly overnight. Guard against this by keeping small bags of silicon-gel crystals in your equipment bags.

bags when not in use. Use reclosable plastic bags for storing film, filters, and other small items.

Desiccants such as silica gel can be purchased in bulk from some camera stores and pharmacies. Buy the largest crystals available so you don't run the risk of particles getting into equipment. Keep tins in your film cooler, camera bags, and small plastic bags.

Humid conditions can wreak havoc with equipment. Air out your camera body and lenses often, and give them a short sunbath whenever you have a chance.

When you're out, give your equipment a sunbath once in a while: a little direct sunshine can help dry things out. But be careful not to overheat the camera. During the day fresh air is better for your equipment than closed bags that absorb moisture and stay damp.

When you get home from an expedition to a hot, humid place, open up everything and dry it thoroughly. You may even want to treat all your equipment to a good cleaning. Moisture is insidious, and if you put away damp equipment, you may find later that leftover traces of dampness have caused corrosion that's expensive to repair.

The best protection for your unexposed film is its factory-sealed packaging; the humidity inside is stable, so don't open a package until you need it. Once you do open film, use it as quickly as you can, and try not to leave a roll in your camera for more than a day.

The best way to ensure that exposed film is safe is to process it right away. If you have to store it, do *not* return it to its film canister. It has absorbed extra moisture while it was out, and if you trap it in that tight little space, the emulsion could be damaged. Instead, place it in a reclosable plastic bag with silica gel until you can get it to the processor.

Of course it's also important to keep yourself as dry as possible. There are many lightweight apparel fabrics, many designed especially for tropical conditions. Look for cargo shirts with mesh pockets for carrying your accessories.

KEEPING YOUR EQUIPMENT CLEAN

Dust and Sand

Hardly anything in the world is worse for your camera equipment than getting grit into it, and if you're in sandy or dusty conditions, it seems like your camera equipment acts like a magnet for the stuff. A few well-placed grains of grit can gum up mechanisms and jam shutters.

Protect your equipment from these elements by carrying all of it in tightly sealed cases. While you're shooting, be aware of blowing sand that can damage lenses.

Before you put your camera away, brush off the exterior thoroughly—we carry a toothbrush to remove sand from around the exterior mechanisms. Or use an air can to blow away all the grit and sand you can. Open your camera back and remove lenses to air-spray your mirror and shutter mechanisms: sand and fine grit act like sandpaper, so *never* wipe away thin layers of them from lenses or filters. Once the majority of the particles have been blown off, finish the cleaning job with lens tissue and cleaning fluid. Clean tripod legs thoroughly after use to avoid damage to connecting joints.

> *Sand and fine grit act like sandpaper on filters and lenses, so never wipe away a thin layer: always blow it off.*

Water

Any amount of moisture can wreak havoc with your equipment. If you're going to shoot around water, make sure your camera strap is in good condition. We keep our camera straps

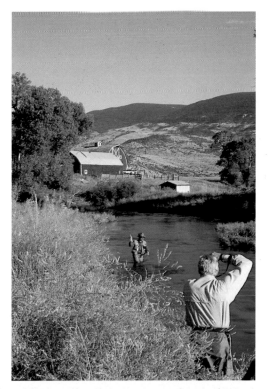

Check your camera strap when you're shooting around water! We tie a tag end of small rope around our belt and attach it to our tripod in case the tripod tips.

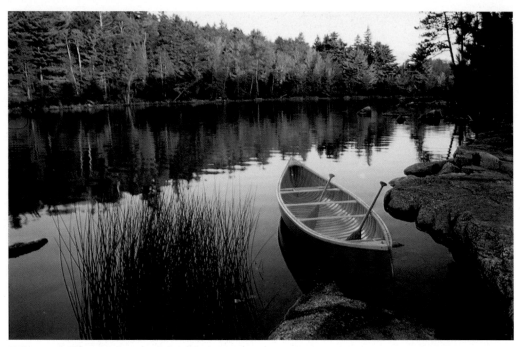

When traveling by boats of any kind, keep your equipment in a waterproof case. Canoes are notorious for dumping cameras into the water.

slung loosely around our necks even when the camera is on a tripod. When traveling by boat, carry equipment in waterproof cases.

If you intend to shoot in the rain, protect your equipment at all times. You can make a crude covering for your camera by cutting a hole in a plastic bag that's just big enough for the lens to extend through. Tie the bag around the camera body to seal out water. If you can shoot under an umbrella or some other covering, that's even better. Tuck your camera inside your own poncho or rainwear when you're carrying it. Be very careful around spray. Waterfalls throw a lot of water, even when you think you're far enough away. Salt spray is even worse.

> **The most important advice if your camera goes into the water: get the batteries out immediately. They will cause irreparable damage if left in.**

We shoot around water a lot, so we're especially careful with our gear. But accidents do happen. Until recently we were very proud of the fact that we'd never dunked a camera. Then last year, despite all precautions, two of them were dropped into streams.

Water will ruin your camera unless you take swift action. The most important advice: get the batteries out of the camera immediately! They will cause irreparable damage if left inside. Then get the camera to a repair shop as soon as possible. It will need to be taken apart and dried thoroughly.

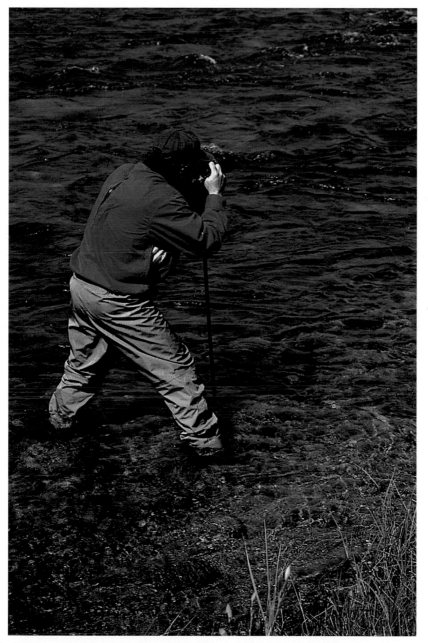

If you do drop your camera into the water, remove its batteries immediately and take the camera to the repair shop as soon as possible. Our friend Jim is captured here using his wading/hiking staff with a camera adapter.

If you simply splashed the camera or lens, you may be able to dry it yourself: open up the body and use a blow dryer for everything you can reach. Or heat an oven at a very low setting—so plastic parts won't melt—then turn it off and place the camera inside. Salt water is

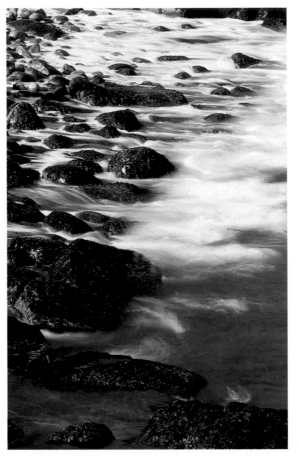

Salt water destroys cameras—splashing can cause corrosion, and immersion will probably damage a camera irreparably. We are especially careful around salt water, and always wipe our equipment down thoroughly with a silicon cloth at day's end. We use a lens-cleaning solution to make sure there are no spots of saltwater spray left on our lenses.

particularly harmful—if your camera is completely immersed in salt water, it probably won't be salvageable.

If you drop film into water, you've probably caused some damage, though all might not be lost. Water causes the emulsion to soften and come apart. But take the film to the processor anyway. It will only cost you $10 or so to see how the pictures came out, and you might be surprised. A friend of ours once had an important roll of film washed and dried with his laundry. He assumed it was destroyed but sent it through anyway—and he was able to salvage some images. You never know.

CHAPTER 10

Storage and Display of Prints and Slides

Much of the pleasure of photography comes after the pictures are taken and you can share them with others. Sorting your images and arranging them for viewing can be as much a part of the creative process as actually shooting.

The key to getting the most out of this process is organization. Even if you're a casual photographer, you'll find that a simple filing system will make it much easier to locate your images. A small notebook detailing the contents of a roll of film will help a lot. Start with "Roll 1" and note the date and the subjects. Later, when you're trying to locate an image, you should be able to identify the roll from a quick perusal of this journal.

> *A simple filing system will help you organize your images. A small notebook detailing the contents of each roll of film is a good start.*

Use whatever system seems logical. A chronological record, such as "July 99, roll 5" may be adequate. Or you might sort by theme or location. Whatever method you use, make sure it's one with which you're comfortable, or you may not follow up with it.

Software packages that help you organize your images have many advantages, but be sure you like to use computers, because they require a lot of record maintenance.

Advances in technology have made it easier than ever to file images. It's possible to have all your images put onto a floppy disk at the same time you develop your film; or you can store your images on CDs. In addition, there are some good software packages available to help you organize your images. These allow you to sort by many different methods: if you want to pull your flower photographs, for example, you can simply sort the database accordingly, and it will locate images that were taken years apart. But be sure you like to use computers. We know people who've invested in software packages to organize their images, but then never used them. On the other hand, we know other folks who couldn't live without their databases.

STORAGE

Your finished prints and slides are subject to damage from some of the same environmental factors that can hurt your film. Bright sunlight causes fading, and high temperatures can damage the paper or film on which your images are recorded. Humid conditions can cause mold or fungus to grow.

Slides

To keep slides in good condition, we recommend storing them in plastic sleeve holders, full-sized sheets that hold twenty 35mm slides. They can be sorted easily for filing and fit nicely into file cabinets, ring binders, or boxes. Choose slide pages that are made for archival storage, and keep them in a room with consistent temperature and humidity levels. Slides stored this way will stay in good condition for many years.

Sort through your slides with a discriminating eye and discard any that are clearly inferior due to poor exposure or soft focus.

If you use slide film, you may want to invest in a light box. Used along with an 8× magnifying loupe, it will make it easy for you to edit your images. Other types of slide viewers display your slides one at a time but are more time-consuming to use, because slides have to be fed into the viewer in stacks. Light boxes allow you to view your images all at once and to compare similar subjects.

Sort through your slides with a discriminating eye, and discard those that are clearly inferior due to poor exposure or soft focus.

Arrange slides by theme or story. And take your time: the work you do now will make it easier to put together shows later.

Prints

You can have color negative film printed in postcard-sized prints or as contact sheets, which record all the images on the roll at actual film size. They are convenient for identifying specific images or editing out poor images, and also make identification easy because they show the frame number. We sometimes have both made and file the contact sheet and negatives, but keep the prints out to share with friends or to display. It can also be fun to have your prints put onto a disk at the same time the film is processed. If you like to play with computer graphics, these disks make it easy for you to place one of your images in a newsletter to friends, customize your desktop, or send photo e-mail messages.

If you make prints, you'll find it helpful to record the frame number on the back of the image as soon as you get it back from the processor. Assign the roll of film a number, then record the negative frame. For example, 6-23 could indicate that your print was made from the negative in roll 6, frame 23. You can use the card index boxes that are made specifically for filing small images, or place your images in an album. Either way, they'll be protected from the elements and stay in good shape for many years to come.

Record the frame numbers on the backs of your prints as soon as you get them back from the processor. Assign the roll of film a number, then record the negative frame.

DISPLAY

The Slide Show

We can't think of a more enjoyable way to share our photographs than a slide show. Having our images projected onto a screen brings out all their vibrancy and energy, and shows them off to their best advantage.

A slide show can be as simple or complex as you want it to be. At their most advanced, slide shows are an art form unto themselves, and can be configured in combination with more than one projector to fade one image as another comes up. Most of these dissolve units can even be programmed with a tape recorder to synchronize the entire slide show with words and music.

A basic slide show requires only a projector, a screen, and a darkened room. If you have a really dark room, you may be able to use a white wall instead of a screen. We find the most

convenient projector is still the classic carousel, which has rotary trays that hold 80 or 140 images. Different models offer a variety of features, from auto-focus and interchangeable lenses to remote controls and sequenced timers. For a more ambitious presentation you can buy accessories that link more than one projector, embed signals that make the show run automatically, or add music and text.

A good slide show probably won't exceed 15 to 20 minutes in length, and will include only about 80 slides.

Decide what you want to accomplish with your show. Are you trying to tell a story, or is it a travelogue of your trip? Is your show designed to convince others of your point of view or just to share the pleasure of an adventure? Whatever you're trying to accomplish, keep the audience in mind when you compile your images. When in doubt, keep it short. Most people enjoy slide shows—unless they're too long. A good slide show, in fact, probably won't exceed 15 to 20 minutes, and will include only about 80 slides; plan to have your images on the screen for an average of 10 seconds each. If you're making a particular point, you can leave an image up for 30 seconds, but this should be an exception. We find that the most interesting slide shows mix short series of images that last only a few seconds with detailed images that stay onscreen for a few seconds longer.

If you think you couldn't possibly tell your story in so little time, think again. We remind ourselves of a quote from Pascal: "I have made this letter a rather long one, only because I didn't have time to make it shorter." It's true that it might take more effort to distill all your images down to the ones that best tell your story, but it's definitely worth the effort.

Many stories are most logically told in the sequence in which you shot the pictures. It helps to have a plan before you start loading the slide tray. We often jot down an outline, get the major photo sequences identified, then start putting it together.

Use little details to help you transition themes. For example, if you're moving from the geysers of Yellowstone to bison grazing in the fields, you might use shots of flora that grow in the geyser region followed by flowers that grow in the open wildlife areas.

When a slide show is created with the same care and imagination that go into your photography, it takes on a life of its own. A well-produced slide show will display your work at its best and give you a reputation as not just a photographer but a storyteller, too. We keep our favorite slide shows together, ready to show again. Local organizations or groups are often on the lookout for speakers who have shows or talks readily available. If you belong to a group such as this, offer your services. You'll discover the pleasure of sharing your work with others, and you may find that you soon have others asking you when your next show will be ready to see.

Prints

Many people think that displaying prints means picking that one special image and enlarging it as a stand-alone object. But prints do as good a job of telling stories as slides do, whether you decide to display them in your album or on your wall.

If you decide to use albums, first decide on the shape and sequence. When we first began making albums, we went with a library approach: all our albums were exactly the same size and shape, and they were cataloged by subject. But as time went on we found that some subjects fit better into other album sizes, shapes, and designs. Soon our album designs became an integral part of our overall presentation plan. Now we have lots of different shapes and sizes—definitely not as easy to store, but a lot more fun to view.

Consider the print sizes you intend to use. Are you going to catalog all your 4-by-6s in one book, in chronological sequence? Then you might be comfortable with an album that has specifically sized pockets. Or are you going to have an assortment of sizes made from your negatives? Then you may want to consider styles that use magnetic sheet pages.

If you use one album for more than one subject, you can indicate the transition with a change of background color or with chapterlike headings. Caption your album as you go, either by hand or using stenciled or computer-generated headings. They will add interesting details to the story and bring a sense of organization to the album.

If you prefer to show your images in frames, consider telling a story with a sequence of images, instead of just one. Try grouping images with similar themes. There are a number of ready-made frames on the market designed specifically for storytelling, with mattes cut out to contain a number of shots. Or you can cluster separately framed pictures together.

To create a harmonious collection, batch similarly colored frames together. An informal arrangement can be made up of different frame sizes. A more formal arrangement will be achieved with frames of the same size grouped together.

Again, this part of photography is as much a part of your artistic expression as taking the pictures. Experiment! You'll find that having your pictures displayed for everyone to see gives every room a personal statement of your interests and taste.

Arranging the prints in albums can be as much a part of your creative process as actually shooting the pictures.

Glossary

AE Automatic exposure. There are three different types available: aperture-priority auto exposure; shutter-priority auto exposure; and programmed auto exposure.

Angle of View The angle at which the lens views the subject. Wide-angle lenses such as a 28mm lens have a wide angle of view, and the subject appears smaller. Telephoto lenses such as a 300mm have a narrower angle of view, and the subject is magnified and appears larger.

Aperture The opening in a lens that controls the amount of light passing through the lens to the film. The size of the aperture-opening adjustment is variable and is referred to as the "f-stop."

Aperture-Priority Auto Exposure The shutter speed is automatically selected by the camera to match the photographer's manually set aperture for a correct exposure. This is used when the photographer wants to control depth of field.

ASA American Standards Association; replaced by ISO in film speed.

Auto-Focus Available on many SLR and fully automatic cameras, a feature that automatically keeps subject in sharp focus. Auto-focus usually can focus quicker than the photographer can manually.

B (Bulb) Used for long time exposures. At the B setting, the shutter remains open as long as the shutter-release button remains fully depressed.

Back Lighting Illuminating the subject from a position opposite the position of the camera, or lighting from behind the subject. Back lighting brightens the dark edges of a subject to outline the subject.

Ball-and-Socket Head Tripod head with one handle that moves the camera in all directions. These heads tend to be lighter, more compact, and a little faster to use than pan/tilt heads.

Bellows Extension An alternative to extension tubes; adjusts to different lengths so you can increase or decrease magnification without changing accessories.

Bracketing Shooting the same subject at different exposures to ensure the best possible exposed shot. Usually means shooting from ½ to 1 stop under and over the camera meter's recommended exposure.

Cable Release A small push-lever cable that screws into the shutter release and allows a shot without touching the camera.

Center-Weighted Metering Meter sensitivity based on the center of the camera viewfinder.

Color Temperature A scale used for rating the color quality of illumination, measured in degrees Kelvin (K). The temperature of daylight on a sunny day, for example, is expressed as 5500K; that of light from a tungsten lamp is expressed as 3200K to 3400K.

Contact Sheet A sheet of images made from direct contact between paper and negatives. Handy for identifying specific images without having to print the entire roll.

Daylight For outdoor photography on a bright day, direct sunlight and light reflected from the sky combine to produce a natural ambient light with a color temperature of around 5500K (see *color temperature*). Color films for daytime use are called daylight-type films.

Daylight-Type Film A film balanced for proper color rendition when exposed in daylight. With film like this, shooting under a cloudy sky or in shade results in a bluish color cast; shooting at dawn or dusk results in a reddish cast.

Depth of Field The area of sharpness in front of and behind the subject on which the lens is focused. Depth of field will vary according to other factors such as focal length of the lens, aperture, and shooting distance.

Depth-of-Field Preview Some SLR cameras include a feature that allows the lens to be closed to the chosen aperture setting, providing a preview of the photo's depth of field.

Diffuser Translucent material placed between the light source and the subject to give more even illumination to the subject and soften the shadows. When using a flash with a diffuser, the greater the flash-to-diffuser distance, the more diffused the light becomes, and the softer the shadows.

Exposure The effect of the light that reaches the film, expressed by the formula: Exposure = Intensity of Light × Duration. Intensity is controlled by lens aperture, and duration by shutter speed.

Extension Tube A hollow, fixed-length accessory that fits between the camera body and the lens; different lengths provide varying amounts of magnification.

Film Speed The rating that indicates film's sensitivity to light, designated by the film's assigned ISO number. The higher the ISO film speed number, the more sensitive it is to light, and the faster it is considered.

Filter Glass or plastic disk that attaches to the lens to absorb or modify the transmitted light as it enters the camera.

Fish-Eye Lens An extremely wide-angle lens with a photo angle of 180 degrees or more.

Flash An artificial light source that is either built into the camera or is attached to the camera. Flash is an intense burst of light used as a supplement to natural light sources.

Focal Length The distance between the optical center of the lens and the film plane when the lens is focused on infinity. In 35mm cameras, 50mm is considered a normal lens.

Focusing Screen Located in a position that is equivalent to the film plane, and used to focus and compose the subject. In some SLR cameras the focusing screen can be changed to suit the needs of the photographer.

Focus-Priority Auto-Focus Setting on auto-focus cameras that prevents the shutter from being released until the subject is in focus.

Front Lighting Illuminates the subject from the position of the camera. Illumination falls evenly upon the subject, so a front-lit subject may look flat and less three-dimensional.

F-Stop The numerical expression of the relative aperture of a lens. This is equal to the focal length divided by the aperture of the lens opening. Each f-number is 1.4 times larger than the preceding one—f4 to f5.6 to f8, and so forth. Each number is a halving or doubling of the amount of light that passes through the lens and available to strike the film. The next-higher f-number always allows one-half as much light; the next-lower f-number allows double the light. The most common apertures found on cameras: f1.4, f2, f2.8, f4, f5.6, f8, f11,

f16, f22, f32. The aperture number represents the diameter of the diaphragm through which light passes to reach the film and controls the depth of field in the photo.

Graduated Neutral-Density Filter A filter that is neutral gray on the top and graduates to clear; used to bring balance to a picture that has a wide range of exposures within the same frame. A common use for this filter is to use the neutral gray in the upper part of the picture to bring the bright sky exposure close to the foreground exposure.

Gray Card A piece of cardboard that is an 18 percent reflectance middle-tone gray color; allows you to find the proper midtone exposure for the subject.

Incident-Light Exposure Meter A handheld meter that measures the light falling on a subject. Not affected by a subject's reflective properties. Should be positioned near the subject.

ISO International Standardization Organization, assigns numbers to film that indicate speed or relative sensitivity to light.

Landscape Format Composition of image in a horizontal direction.

Lens Coating A layer or multiple layers of thin antireflective materials applied to the surface of lens elements to reduce light reflection and increase the amount of transmitted light reaching the film. Most lenses today have an integrated multilayer coating.

Macro Lens Lens with a built-in extension tube, specifically designed for close-up photography with virtually no distortion.

Manual Exposure The photographer sets both the aperture and shutter speed manually. This mode allows the photographer total control to create photographs with any exposure.

Matrix Metering An advanced camera light-metering system that uses a multisegment sensor and computer. The algorithm used is based on extensive shooting data. With matrix metering you have a high likelihood of a correct exposure for most lighting situations, including scenes that incorporate the sun and backlit subjects.

Middle Tone The gray tone halfway between light and dark. The exposure meter chooses the correct exposure for recording the subject in the midrange between light and dark—the same 18 percent gray-tone reflectance of the standard gray card (see *gray card*).

Monopod A simple one-legged stand that helps stabilize the camera.

Motor Drive Advances the film automatically. Many new automatic cameras have built-in motor drives that can be adjusted to advance film from 1 frame per second to as many as 5 frames per second.

Multiple Exposure Created by taking two or more pictures of different subjects, or successive pictures of the same subject, on the same frame of film.

ND (Neutral-Density) Filter A neutral gray lens filter that reduces the amount of transmitted light without affecting color balance. It is available in different densities that are used to reduce the amount of light striking the film.

Negative Film Represents the subject in reversed tones—bright parts of the subject are reproduced in dark tones in the developing process. When reproduced with reversal processing on negative type photographic paper, the image appears similar to that of the original subject. This is the negative/positive system.

Normal Lens For a 35mm camera, normal refers to a lens size of 50 to 55mm, because this size provides an angle of view that's close to that of the human eye, about 45 degrees.

Normal Lighting The same as front lighting, illuminates only the parts of the subject that are facing the camera. Because it imparts few shadows, it tends to create a fairly flat effect.

Panning A technique used to follow the motion of a subject by moving the camera with the subject. This is used to convey the image of speed or to freeze the moving subject using slower shutter speeds, leaving the background in a blurred state.

Pan/Tilt Head Tripod head that has separate handles for every direction of control. Provides precise movement of every camera direction, but tends to be heavier and more time-consuming to use than a ball-and-socket tripod head.

Perspective The relative size, distance, and depth of a three-dimensional subject or scene within a two-dimensional, flat picture.

Polarizing Filter Eliminates glare or reflection from surfaces by reducing reflected light from objects. The true colors come through to the film, resulting in more saturated colors. Most polarizing filters are linear polarizing filters; circular polarizing filters convert linear polarized light waves to circular light waves.

Portrait Format Photographs that are formatted in a vertical orientation, so-called because they are often used for head-and-shoulder photographs of people.

Print Film Film processed as a negative image—dark areas appear light in the negative and light areas appear dark—from which positive prints are made. Black-and-white and color print film are the most common films used. (See also *negative film*.)

Programmed Auto Exposure The camera automatically selects the optimum combination of shutter speed and aperture. Available programs include auto multi-program and vari-program, which allow the photographer to select the most suitable program for the desired results.

Pushing Film Setting the ISO dial on the camera at a higher speed than the film is optimally designed for. This must be compensated for during development by having the film push-processed 1 extra stop for the entire roll of film.

Reflected-Light Exposure Meter Measures light reflected from the subject. The exposure meter built into SLR cameras is a type of reflected-light exposure meter, whose readings are affected by the amount of light and subject's reflective properties.

Reflector Accessory used to bounce reflected light toward the subject to fill in shadows.

Rim Lighting A type of back lighting that casts a bright aura of light around the subject or portions of the subject.

Rule of Thirds A guideline for composing images using a grid format. The intersections of the grid lines are strong areas in the photo frame: placing the subject at one or more of these intersections gives the photograph more tension and is often more appealing to the eye.

Screw-on Close-up Filter Inexpensive alternative to both extension tubes and macro lenses for close-up photographs, functions like a magnifying glass, bringing small images up close.

Self-Timer A feature found on many SLR cameras that is designed to delay the operation of the shutter by several seconds. Allows a 10-second delay after the shutter button is released before the shutter operates.

Shoulder Stock For photographing birds in flight or stalking moving animals. Available in a number of styles, from lightweight aluminum supports that balance on your chest to wooden or plastic gun-stock styles.

Shutter-Priority Auto Exposure The lens aperture is automatically selected by the camera to match the photographer's manually selected shutter speed for a correct exposure. This is used when the photographer wants to control motion to stop action or create motion effects using slow shutter speeds.

Shutter Speed Measures how long the camera shutter will be open to let the light reach the film plane. Most camera shutter speeds range from B up to 1/4000 second. Shutter speeds are referred to by only the denominator of the fraction: a speed of 1/125, for instance, is called 125, and this is how the speed appears on the shutter-speed dial. Therefore, the higher the number, the faster the shutter speed. Shutter speed is used to control how motion is recorded.

Side Lighting Illuminates the subject from either side, producing more shadows on the subject than front lighting. It is used to give the subject more definition or depth.

Skylight Filter Corrects the excess bluish cast that results from taking pictures in the shade on clear bright days. It is often used as a protective lens filter, because it does not affect the exposure.

Slide or Reversal Film Also called positive film. Usually used for slide projection or printing purposes.

SLR Single-lens-reflex camera that employs the same lens for viewing the scene (through the use of internal reflex mirrors) as it does for recording the image on film.

Spot Metering Meter sensitivity concentrated within a small circle in the center of the viewfinder, usually 1 to 5 percent of the total area of the viewfinder. It is used for very precise metering.

Stops A measure or increment of exposure. Both shutter speeds and aperture are represented in increments called stops: each stop doubles or halves the amount of light that is allowed to reach the film during exposure.

Sunny 16 Rule A quick way to estimate the correct exposure for bright outside conditions: set the shutter speed the same as (or as close as possible to) the film speed, and set the aperture at f16. Example: if the film speed is ISO 125, the shutter speed should be set at $\frac{1}{125}$ second. (Using this equation, the aperture is always set at f16.)

Teleconverter An optical element that is placed between the lens and the camera to increase the focal length of the lens. The two most common teleconverters are $1.4\times$, which increases the focal length of a 400mm lens to 560mm and reduces the aperture by 1 f-stop, and $2\times$, which increases a 400mm length to 800mm and reduces the aperture by 2 f stops.

Telephoto Lens In 35mm photography any lens over 85mm is considered telephoto. Telephoto lenses have longer focal lengths, have a narrower angle of view, and magnify the image in proportion to the focal length. Short telephoto lenses are 85mm to 135mm; medium telephoto lenses are 150mm to 200mm; and long telephoto lenses are 300mm and above.

Transparency A positive image viewed by transmitted light rather than reflected light. Once mounted, they are called slides.

Tripod A three-legged camera support with collapsible legs and a separate adjustable head mount to which the camera is attached.

TTL Through-the-Lens, used to refer to exposure systems that read the light that passes through the lens to strike the film.

Tungsten Light Light from a photo lamp has a color temperature of 3200K to 3400K. Under a tungsten lamp, images on daylight-type film tend to take on a reddish cast.

Tungsten-Type Film A film balanced for proper color rendition when exposed under tungsten light. When a tungsten-type film is used in daylight or with illumination from a flash, use a color temperature conversion filter such as the A12 to prevent the appearance of a bluish cast.

UV Filter Used to absorb ultraviolet light, to cut haze on overcast days, and in high mountain terrain. This filter has no effect on exposure.

Warming Filter Usually an amber-toned filter, such as the 81A-EF series, that is used to increase the warmer color spectrum of a photograph.

Wide-Angle Lens In 35mm photography any lens less than 50mm in focal length. These lenses have shorter focal lengths and a wide angle of view; they make the image smaller in proportion to the shorter focal length. The most common are 24mm, 28mm, and 35mm.

Zoom Lens A lens of variable focal length that can be adjusted from the lowest focal length to the upper focal length to change the scale of the image without throwing the image out of focus. Examples of common zoom lenses are 35–70mm and 70–200mm.

Index